Starting in Watercolour

CHARLES BARTLETT

Series Editor
Ken Howard

BLOOMSBURY

To Olwen for her patience and help

First published in 1988 by Bloomsbury Publishing Limited,
2 Soho Square, London W1V 5DE
Copyright © Swallow Publishing Ltd 1988

Conceived and produced by
Swallow Publishing Ltd, Swallow House,
11-21 Northdown Street, London N1 9BN

Editor: Anne Yelland
Art director: Elaine Partington
Designer: Jean Hoyes
Photographer: Tim Imrie
Studio: Del and Co.
Printed in Spain by Mateu Cromo

Note: Throughout this book, American terms are signalled
in parentheses after their British equivalents the first time
in each section they occur. In frame and artwork
measurement, height always precedes width.

British Library Cataloguing in Publication Data

Bartlett, Charles
 Starting in water colour. — (Art class).
 1. Watercolour paintings – Manuals
 I. Title II. Series
 751.42'2

ISBN 0-7475-0124-6

Contents

Foreword

'I wish I could do that.'
This is probably the most common exclamation by anyone watching an artist at work. Wishing will not achieve it, but it is my belief that most people can paint if they really want to and if they receive some form of guidance. When we are at school it is taken for granted that everyone can be taught to write but not necessarily that they will write great poetry or prose. I believe that everyone can be taught to paint for their own pleasure but that does not mean that they will paint masterpieces. Great artists are born, but how can we know whether we are an artist or not until we have learned to paint?

Art Class is a series of titles geared specifically to the requirements of the amateur painter. Some of the books are technique-based to help you to acquire first the basic, then the more advanced techniques you need to enable you to work in a particular medium. Others are subject-based, outlining the theory and principles which you should understand in order to produce pleasing and technically adept works of art. All are full of sound practical advice, and suggest exercises and projects which you can do in order to gain a clear understanding of the subject. All the writers involved in the series, as well as being professional artists, have at some time in their careers been involved in teaching in art schools; indeed I have had the pleasure of teaching with several of them myself.

Charles Bartlett is a man of great experience in both the practice and teaching of watercolour painting, and is President of the Royal Society of Painters in Water-Colours, the latest in a long list of the most distinguished painters in this particular medium. His own watercolours are full of experiment and verve and in this book he encourages the same lively approach.

In the past, artists learned to paint by going to work in the studio of a distinguished artist; there they would learn all about materials and methods, as well as composition and creative ideas. This, for reasons too complicated to analyse here, is no longer possible, but in this book Charles Bartlett invites you, in a sense, into his studio to learn from his example. He describes materials, based on his experience over many years. He explores watercolour techniques, beginning with the most traditional methods of working with transparent washes, followed by more varied and adventurous techniques. Although he cannot have you sit and watch him work, he does

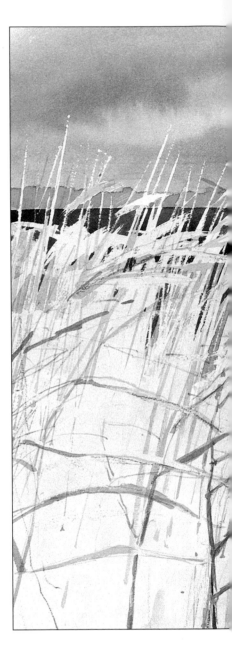

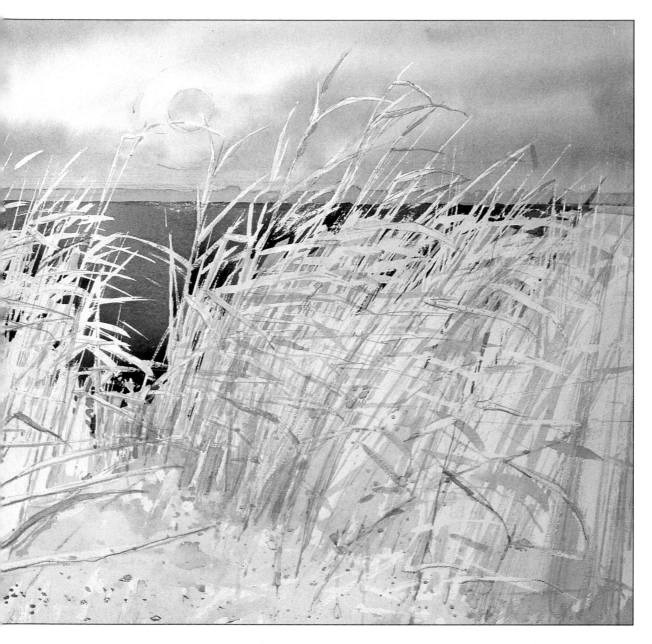

Charles Bartlett 'Reeds'
426 × 575mm (17 × 23in.).
A watercolour from the collection
of the author.

the next best thing and takes you step by step through projects, explaining the development of a painting clearly and concisely.

Charles Bartlett's experience as a teacher, qualities as an artist, and enthusiasm and imagination as a writer are reflected in every page of this book. Read it, absorb it, practise what it suggests and in the years to come you may well become a considerable painter in watercolours.

Ken Howard

Introduction

Watercolour painting has a long and living tradition. There are paintings in watercolour in the caves at Altamira and at Lascaux, making it likely that this is the earliest method used by man to record his existence. From that time, people from almost all cultures – including the ancient Egyptians, the Chinese, and the European and English masters of the eighteenth century – have taken the tradition, added to it and developed it. Today, the popularity of watercolour, even in the face of more modern alternatives, seems undiminished, and certainly it is a medium which still attracts many beginners to painting every year.

Watercolour is often called the 'English' medium, although English landscape art really developed from the Dutch school of painting – the two countries are, after all, very close to one another. The topographical artists in England – who were trying to make accurate records of what they saw, usually landscapes, and architectural and botanical drawings – drew their subjects, and then stained them lightly in watercolour, normally pale brown or green. The Dutch influence encouraged a more painterly approach. The French, and through them, the Italian landscape schools also played a part in the development of English watercolour art.

There are many reasons why watercolour painting flourished in Britain around 1800. The Industrial Revolution meant that more people had more money, but it was also a time when people of culture started to travel widely – the 'grand tour' became an essential part of a gentleman's education – and they began to collect works of art. Thomas Gainsborough and Paul Sandby were just two of the great artists who started the Royal Academy and who were instrumental in encouraging collecting, and the vogue for amateur painting. At about this time, there was a large number of gifted and enthusiastic artists using watercolour as a creative medium. The Royal Society of Painters in Water-Colours was formed in London in 1804. Watercolour painting in America owed a great deal to European art in the nineteenth century. In this century, however, a strong national style has developed. As well as producing some brilliant professional artists, the American interest in watercolour painting has encouraged amateur artists and the number of amateur painters in watercolour has increased enormously over the last twenty or thirty years.

Paul Sandby 'Windsor Castle: the Round Tower' 290 × 510mm (11½ × 20½in.). Some of Sandby's most interesting works are his numerous drawings of Windsor Castle. This example is one of his best; it is transparent watercolour over pencil and is a good example of topographical painting in which the drawing predominates.

Charles Bartlett 'Fishing Boats' 350 × 425mm (14 × 17in.). An example of the use of transparent watercolour where the drawing is established by shapes of colour.

6

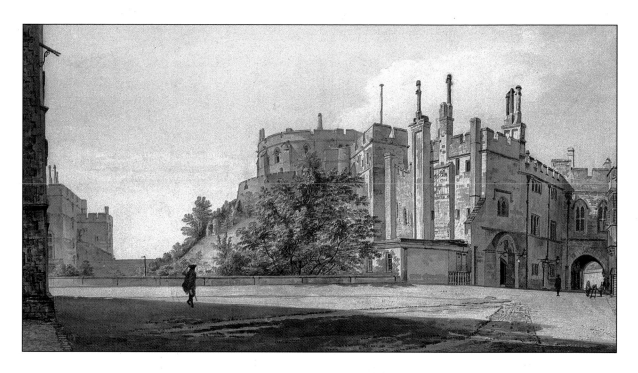

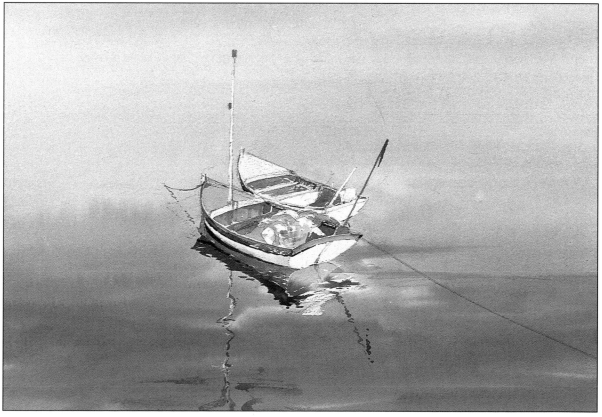

This book is designed to help those people who want to know how to paint in watercolour. It illustrates basic principles and techniques from which you can develop your own approach to the subject and your own personal style. Equipment and materials are listed with advice as to what is necessary and most suitable for the beginner, and the book gives practical instruction and encourages you to carry out specific projects and exercises. If you follow the guidelines and advice given and work systematically through the projects, by the time you reach the end of the book you should be able to produce satisfying and technically adept paintings.

For me one of the great charms of watercolour painting is its fluidity and transparency, which can produce a beauty which is unique. I find the spontaneous quality, the simplicity and ability to express mood and light suits my expression as an artist. But one has to be careful that the medium and technique don't become all important; first and foremost one is an artist with something to express.

I believe that the beginner in watercolour is best advised not to spend years learning the academics of drawing first, but rather to start painting and let the drawing develop alongside. They should run hand in hand. Drawing and observation are fundamental to painting and will improve with practice. Enjoy your painting, paint what you know and love best and don't worry too much about what other people say or think.

There are three main styles of watercolour painting. The watercolour drawing (below left) is the traditional use of the medium (as used by the great topographical artists). The drawing in pen or pencil tends to predominate, and the colour is applied in light transparent washes simply to tint the drawing. Watercolour painting (which is the method of painting mostly dealt with in this book) relies on transparent washes of colour laid over white or pale paper. Some drawing is indicated but the painting is largely colour against colour (right). Gouache (or body colour, below) is the use of opaque watercolour. Its consistency, opacity and visible texture make it different from the more traditional use of watercolours.

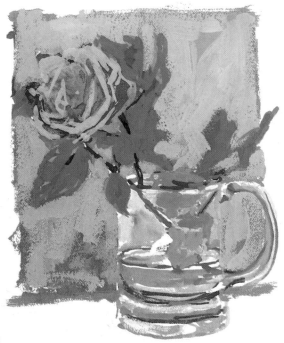

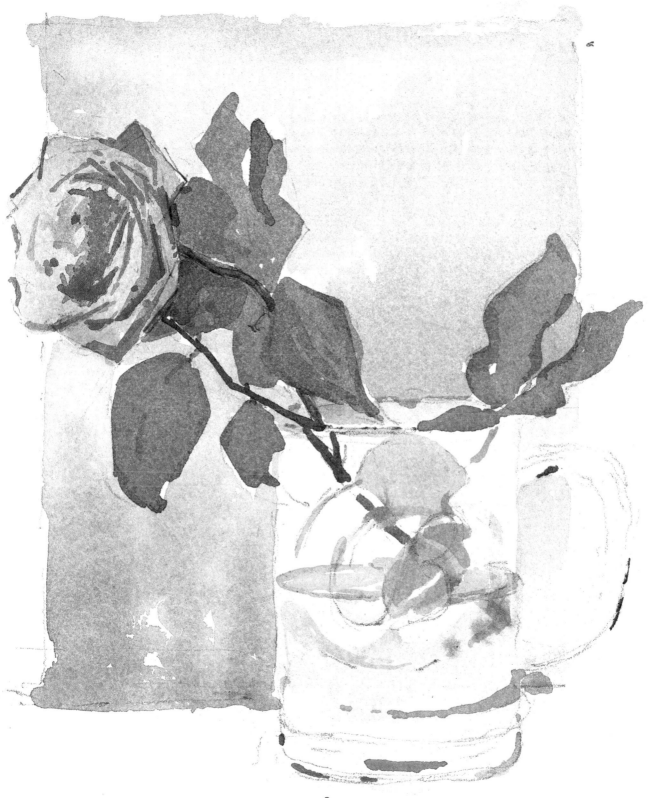

Materials and equipment

There are three basic essentials for painting in watercolours – paper (usually called the support), paints and brushes. However, as you will see from the descriptions below (and as a visit to a reputable art supplier will show you), there is a wide range of choice in each of these items. In this section, all the materials and equipment you are likely to come across are considered and the major differences between them discussed.

Paper

Paper is available in a large variety of sizes, weights, qualities and colours, but white or lightly toned papers are the most useful for watercolour. The best papers are hand made from pure linen rags. Mould-made papers are cheaper and quite satisfactory as long as they are made from linen or cotton rags.

Paper comes in three different finishes: Hot-pressed, Cold-pressed (or 'Not', meaning simply not Hot-pressed) and Rough. The surface of

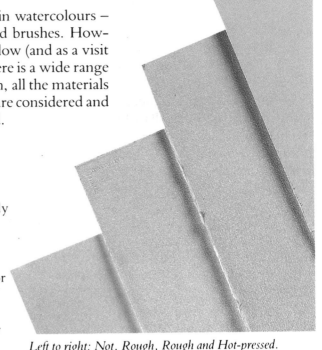

Left to right: Not, Rough, Rough and Hot-pressed.

PAPER TEXTURE

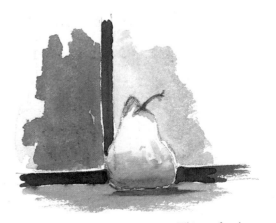

Smooth Hot-Pressed 140lb (295gsm) paper. This paper is the most delicate and sensitive, it is lovely to draw on and probably the most useful for watercolour drawing. It is, however, difficult to control large washes on it and dark colours often go patchy.

Medium Not 140lb (295gsm) paper. This surface has enough texture to produce a delicate painting but also the ability to break up the paint and give crispness in handling. This paper takes washes well and is probably the paper most often used by watercolour artists.

Hot-pressed paper is the smoothest and most absorbent, so this type of paper is less suitable for the transparent watercolour technique than either Not or Rough, both of which take a wash more easily. Not is a textured semi-rough paper which is good for large smooth washes, yet it will also take fine brush detailing. Rough paper is rough textured, and a wash will not always fill the crevices in the surface, presenting a slightly speckled effect. It lends itself to dry-brush techniques (see pages 38-9), but it is difficult to paint fine details on this type of paper. For these reasons Not and Rough are the two most favoured surfaces for watercolour painting; Hot-pressed is more suitable for, and used more often for, drawing or pen work.

Paper is graded by weight, either by pounds per ream (500 sheets) or grams per square metre (gsm). The most common weights available are 72lb (150gsm), 90lb (185gsm) and 140lb (295gsm). Generally, the larger the painting you intend to do, the heavier the paper you use should be, so 72lb (150gsm) is suitable for small paintings and

Paper sizes		
Double Elephant	686 × 1001mm	(27 × 40in.)
A1	594 × 840mm	(23½ × 33in.)
A2	420 × 594mm	(16½ × 23½in.)
Imperial	559 × 762mm	(22 × 30in.)
½ Imperial	381 × 559mm	(22 × 15in.)
Royal	490 × 610mm	(19½ × 25in.)

sketches, 90lb (185gsm) for moderate sized works, and 140lb (295gsm) is necessary for larger works. Traditional Imperial sizes are retained in Britain and the United States for better quality hand- and mould-made papers. For other papers, including cartridge (drawing), the international 'A' sizes are more common.

I use 90lb (185gsm) and 140lb (295gsm) paper, usually Not surface, although occasionally for larger works I use Rough surface. I buy Imperial sheets and cut them down if necessary to the size I require. I find I usually have to stretch the paper (see page 12). This is because once you put a wash on a sheet of paper, the water will make the fibres stretch so the paper will wrinkle and become bumpy. You cannot get a smooth wash on a wavy surface. The heavier grades of paper do show less tendency to wrinkle, particularly in fairly small sizes, so if you are going to do a small painting and not get the sheet too wet, the paper will not need stretching. Certainly anything less than 140lb (295gsm) should always be stretched.

Always be careful to use the right side of the paper; the watermark if held up to the light reads correctly on the side to paint on. Stretch a larger piece of paper than you think you will need, as this will give you some room to manoeuvre over your composition. Sometimes you may want to add a bit on one side or the other to make a better arrangement.

Blocks and pads of watercolour paper are useful, particularly if you are travelling light, but wherever possible I do prefer to buy my paper in sheets and stretch it myself.

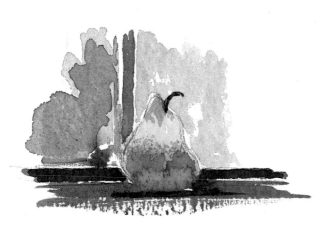

Rough 140lb (295gsm) paper. The surface is very coarse and this gives a broken effect to the paint, often making it rather 'jumping' and lively. This surface is not suitable for delicate subjects and lends itself to large paintings.

STRETCHING PAPER

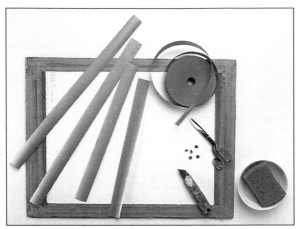

Trim the paper to size. It should be at least 50mm (2in.) smaller all round than the board you intend to stretch it on to. Make sure you use a stout board – not one made from thin plywood or hardboard (masonite). Check the paper for the watermark, when it reads correctly you have the paper right side up. Cut four pieces of 40mm (1½in.) gummed paper strip, one for each side.

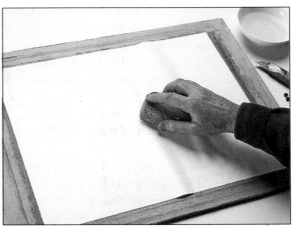

Sponge both sides of the paper – wrong side first – with lukewarm water. Warm water softens the size in the paper faster than cold, but don't have the water too hot or you could break down the fibres in the paper. Apply the water gently in case you damage the surface of the paper. Use a full sponge but don't over-saturate the paper. Lay out the damp paper in the correct position on the boara.

Press out any air bubbles that form gently from the middle to the edge of the paper with a clean rag. Allow the paper to relax for about five minutes (for 90lb/185gsm – allow up to ten for 140lb/295gsm). Wet the lengths of gumstrip, and lay them around the edges of the paper, allowing approximately equal overlap between the paper and board. Rub the gumstrip well down.

Place drawing pins through the gumstrip and paper at each corner to ensure that the paper lies flat. Allow the paper to dry naturally in a horizontal position (this will take a few hours or overnight). The stretching will be spoiled if you use artificial heat. Once it is completely dry, the paper is ready to use.

Brushes

Brushes are the most personal tool an artist uses. For this reason, buy the best you can afford – it is better to have one or two good-quality brushes than several indifferent ones. The best watercolour brushes are, unfortunately (but not surprisingly), the most expensive. They are made from red sable hair, and are soft, springy and very well set in the ferrule. They also hold a lot of water (which makes them ideal for washes) and the hairs always go to a good point. Less expensive natural-hair brushes are made from either ox hair or camel hair. Ox hair is more springy than sable and tougher, but it does not hold so much water or produce such a fine point. Camel hair (actually usually squirrel) is relatively cheap, but it does not have the spring or life of either sable or ox hair, and the hairs often tend to come out of the ferrule. There is also a range of watercolour brushes on the market that combine synthetic fibre with a proportion of sable. These are superior to camel hair and cheaper than natural hair and can be recommended if you cannot afford pure sable.

Watercolour brushes range in size from the tiny 000 to a size 14. The size is directly related to the number of hairs in the ferrule – a No. 10, for instance, has approximately ten times as many hairs as a No. 1. To begin with, I would suggest you buy one each of Nos 2, 5, 7 and 10.

Good brushes are expensive, but will last a long time if they are properly cared for. Always wash out your brushes in clean water before you finish for the day. If the brush is stained, and clean water alone does not remove the paint, wash it gently with lukewarm water and soap but make sure the brush is well rinsed with clean water afterwards. Shape the brush naturally either between your lips, or by gently shaking the hairs to a point. Do not store brushes until they are completely dry. If a brush is in constant use, store it with its bristles upright in a jam (jelly)-jar or similar container. For longer term storage, they can be kept in a brush container or box with some mothballs.

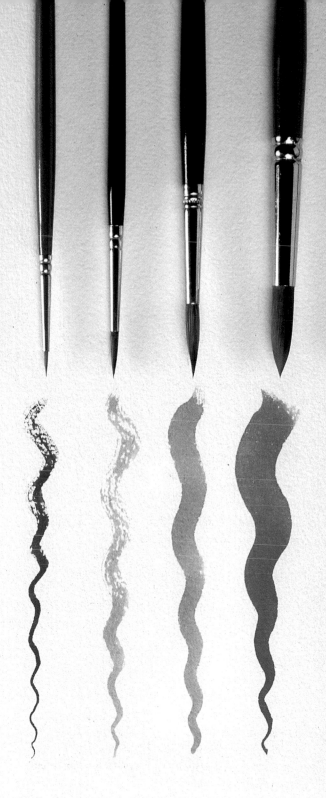

The marks made by watercolour brushes of different sizes: (left to right) Nos 00, 2, 5, and 10.

Paints

The standard of paint manufacture, on the whole, is extremely high and a wide range of colours is now produced. Watercolours are made up of transparent pigments ground extremely finely and mixed with gum. Gouache or designers' colour differs from watercolour in that the colour has precipitated chalk, as well as gum, mixed with it.

Pure watercolour is available in several forms, as dry cakes, semi-moist pans, tubes and bottles of concentrated colour. Dry cakes contain pigment in its purest form; semi-moist pans and tubes usually have glycerine added to keep them moist.

Dry cakes

These are the traditional form of watercolour. The colour in these hard round cakes is pure and is still preferred by some watercolourists. These cakes need more water than pans or tubes to release the colour, and unless they are used regularly, they get very hard and need a lot of scrubbing up.

Pans and half pans

These are small blocks of semi-moist watercolour, which are designed to fit into watercolour boxes which can be purchased separately. You can, therefore, buy the colours individually, making your own selection. Whole pans are slightly more economical, but both offer a strong yield of colour that can be easily worked and diluted. They are very convenient for use out of doors.

Tubes

The colour in tubes is more loosely ground and does not dry out provided the tubes are re-sealed after use. Tubed watercolour is convenient for squeezing out large amounts and is instantly workable, it doesn't need 'scrubbing up'. For this reason, it is probably more suitable for use in the studio or on a large-scale painting. A special box or container is not necessary to hold the tubes – a plastic bag will suffice – and a white plate makes a good palette.

Tubes and pans of watercolour are available in Artists' quality or Students' quality, Students' quality generally being about one-quarter of the price of Artists' quality. All reputable paint manufacturers grade their products according to durability and permanence. Winsor and Newton, for example, classify their Artists' watercolours in four grades of permanence: Class AA Extremely durable; Class A Durable; Class B Moderately durable; and Class C Fugitive. The durability and permanence of Artists' colours should be checked against the manufacturer's colour list – do not select colours which are fugitive.

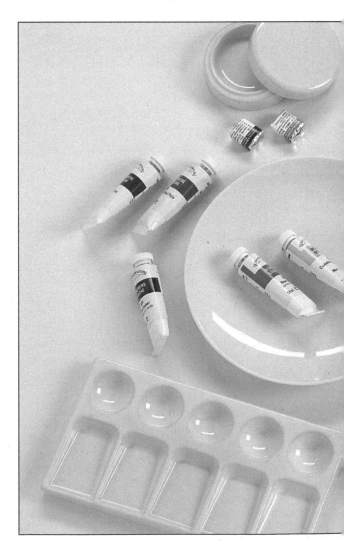

Some of the pigments used in Artists' quality paints are expensive and this is reflected in the price. However, I would recommend you buy the best available materials; in this case, Artists' quality paints. It is a mistake to think anything will do – you will only add to any problems.

Palettes and paintboxes

The watercolour box usually has white enamelled recesses for mixing colour, this is the most convenient form of carrying and using semi-moist watercolours, particularly for outdoor work.

If you are using tube colours you will need well palettes or pots. A conventional kidney-shaped palette is very useful but it must be white and have recesses for mixing colour.

If you are buying a paintbox (or having one for a gift) it is better to choose one that is not too small, say with spaces for about 12 or 14 pans. It should have large mixing pans and clips for holding the pans so that they can be changed. A box with a thumb-hole or ring is easier to hold. Also, buy the paints separately from the paintbox. In this way, you can select colours to suit you and your style of working.

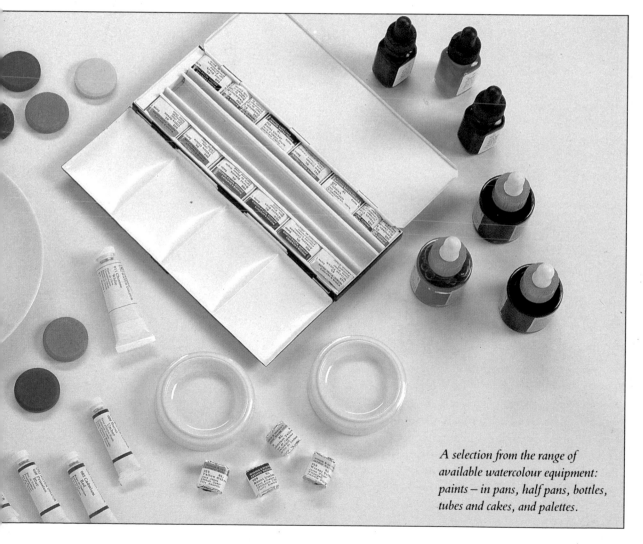

A selection from the range of available watercolour equipment: paints – in pans, half pans, bottles, tubes and cakes, and palettes.

Artists' furniture

Stools

If you are working out of doors a good folding stool is very useful but make sure it is strong and reasonably comfortable. A stool which is too small or too low can mean you get terrible cramp, often just when you have reached a critical point in your watercolour. There are some good light aluminium (aluminum) stools on the market.

Folding table

If you are working at home and have to pack your gear away after use, a folding table is necessary, unless of course you are fortunate enough to have a studio. There are drawing tables (some of which are used in schools) with adjustable angled boards and drawers but the better quality ones do not fold away. An ordinary 1.25m (4ft) wooden folding table is adequate.

Easels

Although an easel is not essential, it is very useful, if for no other reason than it leaves both your hands free. It needs to be the folding type for outdoor work and must be stable and light. There is a three-legged easel on the market which has a pivoting main shaft that can be swung either vertically or horizontally. This makes it useful for standing or sitting to work. Easels are made from wood or aluminium, both of which are reasonably light and satisfactory.

Drawing boards

These really fall into two categories, the one to be used at home or in the studio and the one used for sketching and outdoor work. In the former case weight doesn't matter too much so a good solid ½ Imperial board is what is required (or full Imperial if you have room). For outdoor work it is probably best to make a drawing board out of exterior plywood, in fact make several of different sizes: 38 × 56cm (15 × 22in.), 28 × 38cm (11 × 15in.) and 38 × 45cm (15 × 18in.). You can use

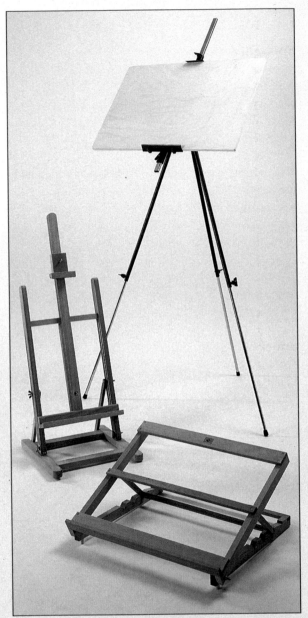

An easel with a pivoting main shaft enables you to stand or sit to work so is probably the most versatile buy, though table top ones are also available.

them to stretch paper on both sides if you get the ply thick enough (otherwise it will bow under the strain of the stretched paper). Use plywood that is at least 7mm (³⁄₈in.) thick for a board 38 × 56cm (15 × 22in.) – it can be thinner for smaller sizes.

Other useful equipment

Sponges of all sizes are useful for dampening a small area, washing off a small area of paint, or painting or creating a texture. You will also need one large one for sponging and stretching paper. Natural sponge is better than synthetic.

Soft cotton rags are useful for wiping your brushes on.

Absorbent paper tissues of any kind can be used for mopping out colour, or correcting a watercolour. It is also possible to create texture with them (see page 38).

A toothbrush is useful for splatter work. The toothbrush is dipped in paint and then a knife is drawn across the bristles; this causes fine splatter or mottling (see page 26).

Cottonwool buds (cotton swabs) are used for mopping out tiny areas of colour, and correcting.

Erasers are necessary for rubbing out pencil or charcoal marks. You will need a vinyl eraser for charcoal, and a soft eraser for pencil. An ink or typewriter eraser can also be useful for taking out small areas of colour.

Pencils are ideal for sketching in lines before painting and planning your paintings, also for making studies and notes. Initially, softer grades are the most useful.

Gummed paper is necessary when you are stretching paper (see page 12) and for sealing the back of frames.

You may find some (or all) of these items useful in your work. Apart from household items like rags, sponges and a toothbrush, you may need a bottle of masking fluid or gum arabic for a particular effect.

Blades, either single-sided razor blades or sharp craft knife blades, are useful for scraping and correcting small areas of paint (see pages 36 and 46). A sharp craft knife is a useful tool for cutting paper and mounts (mats).

Masking fluid protects areas of work when applying washes (see pages 40-1).

Masking tape is necessary in order to fasten paper to boards (although not for stretching paper) and to mask straight lines, for example, the borders of a painting.

Gum arabic is used in the manufacture of watercolour, and is useful to have in the studio for thickening paint and to create a texture.

A palette knife (metal spatula) is a useful implement for spreading paint, particularly gouache, on to paper. It can also be used for moving colour around or for putting small touches of colour into a painting.

Water containers are vital. Plastic bottles with screw tops are the simplest to get hold of, but specially made containers for watercolour painting are available on the market. These have a top which can be clipped on to your paintbox as a water pot. In the home or studio, jam (jelly)-jars or pudding basins are alternatives.

Recommended kit

The items detailed and illustrated here are ones that I consider suitable for a beginner in watercolour. All are readily available and reasonably priced, and with them you should be able to produce good-quality paintings.

Paper Either Arches mould-made Not 90 lb (185 gsm) or T.H. Saunders Waterford Not 90 lb (185 gsm). Both of these papers are ideal for a beginner since they take washes well, yet are sufficiently robust to allow you to sponge out areas you don't like. You should stretch either of these papers before you use it unless you are simply carrying out a small exercise. Both of these papers are readily available from artists' suppliers.

Paints You should have a watercolour box containing the following colours in semi-moist whole or half pans of Artists' quality watercolours: cadmium yellow, yellow ochre, raw sienna, raw umber, burnt umber, light red, cadmium red, viridian, cobalt blue, prussian blue, and neutral tint. Chinese white may also be useful. With this list of colours you can mix almost any shade you need for still-life or landscape painting.

Brushes Nos 2, 5, 7 and 10. The No. 10 could be either ox hair or synthetic as a sable brush this size would be very expensive.

Additional items A ½ Imperial drawing board, either bought or home made; pencils (grades B and 2B); some sticks of vine charcoal; a soft pencil eraser and a vinyl eraser; an easel and stool; water containers – jam (jelly)-jars or plastic pudding basins will do; a sponge; some cotton rags; and a sketching bag (to keep all your equipment in – this is more important for work outdoors).

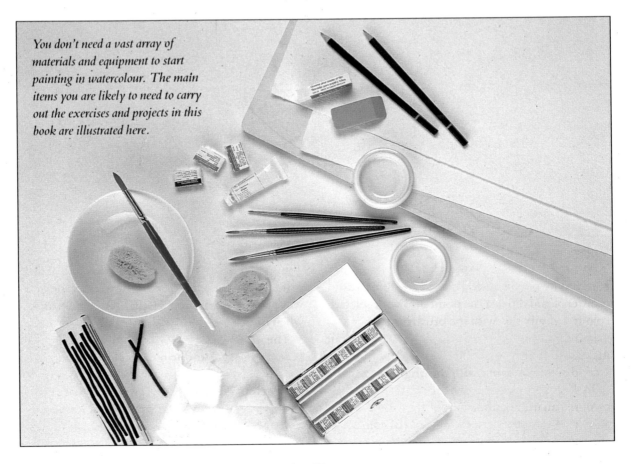

You don't need a vast array of materials and equipment to start painting in watercolour. The main items you are likely to need to carry out the exercises and projects in this book are illustrated here.

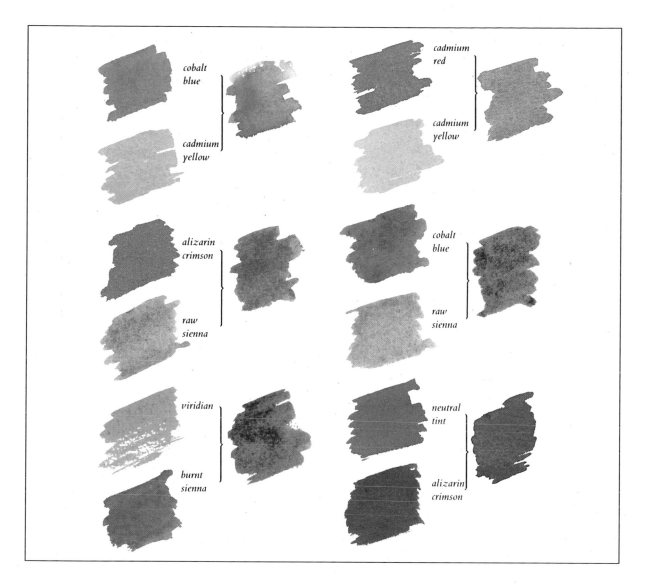

Colour mixing

To mix a colour, first put some clean water into your palette or container, then take a clean brush, moisten it and dip just the point into your selected colour and mix this with the brush into the prepared water on the palette. To vary this colour, make sure your brush is clean, then dip it into the second colour and mix with the original wash.

Make marks on a sheet of paper of all the colours you use and mix. Write against these colour splurges the correct name of the colour you are using, and the colour you make; for example,

cobalt blue + cadmium yellow = green, or cadmium yellow + cadmium red = orange. Cover a sheet of paper with these little exercises and you will begin to learn more about how colours look when mixed with one another.

The more colours you mix together, the greater your chances of producing a muddy brown, so initially at least limit yourself to mixing two or three colours. Also, always make sure that you have plenty of clean water available, at least one container for cleaning your brush and one for use in making your colour.

Starting to paint

Watercolour painting relies on transparent washes of colour laid over a reflecting light-toned paper (unlike gouache which has white mixed with the colour and so can be painted on any coloured paper). This means that to paint successfully in watercolour you must master the basic technique of laying a wash. For any area you wish to paint which is too large for a simple brush stroke a wash is necessary.

In all successful paintings a satisfactory composition depends upon simple flat areas (washes) being played against complex areas. One only has to study a watercolour by John Sell Cotman or David Hockney to realize the importance of a flat wash. If you start by mastering this technique it will give confidence and lead you into both the fun and the mystery of watercolour painting. It is a bit like learning scales if you want to play the piano, both need a lot of practice. After you have bought the equipment suggested on page 18, take and stretch several pieces of watercolour paper – for these experiments they do not have to be very big, about 25 × 30 cm/10 × 12 in. should be large enough – and practise laying washes as described opposite.

You will need
- ☐ a drawing board with stretched paper
- ☐ two jars of clean water
- ☐ paints
- ☐ brushes
- ☐ a white plate or palette
- ☐ a stick of charcoal
- ☐ a soft pencil and eraser
- ☐ masking fluid
- ☐ razor or craft knife blades

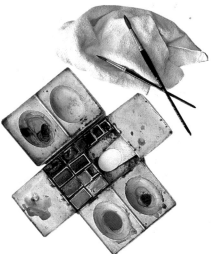

This paintbox is well designed: it has a thumbhole for ease of holding, there are four deep mixing pans, spaces for ten whole pans of paint, and it is robust, yet not too heavy.

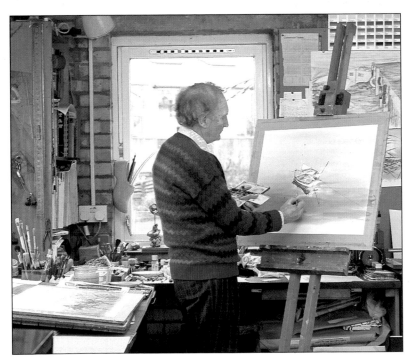

The author in his studio, showing details of worktop and watercolour equipment. Normally, work is done on the workbench but it is useful when putting finishing touches to a painting to use an easel; it enables you to stand back from the work.

Flat washes

A flat wash is an even distribution of transparent watercolour, and laying one is the basic technique of all pure watercolour painting. There is something very seductive and beautiful about a lovely watercolour wash.

To mix the colour for the wash, first put a quantity of water into your container (for large washes separate porcelain stacking palettes/cabinet nests are very useful). The quantity will vary according to the area you wish to cover but on an average start with about a small egg cup (4 tablespoons) of water. Add the colour by moistening your brush and with the point lifting the paint from the pan. The more paint you add to the water, the more intense the colour will be but remember that the watercolour will always dry lighter than it looks when it is applied. It is easier to lay a flat wash on a Rough or Not surfaced paper and if the area you wish to cover is fairly large and simple it will help your wash if you dampen the paper first. (If you were painting around small shapes, this would not be possible.)

Use as large a brush as possible, depending upon the complexity of the area. Keep the board tilted at about a 30 degree angle and start at the top of the sheet with a well-loaded brush. Continue backwards and forwards horizontally, working left to right and right to left down your paper.

Work systematically at the speed the wash runs, so that you always pick up the band of colour that is forming at the bottom of the stroke. This means that if you are working with a very watery wash you will have to work faster than if you are using a wash with a higher proportion of colour in it.

When you arrive at the bottom of your paper you will find a surplus pool of colour gathering. Mop this up with a squeezed out brush or sponge. If you don't, you will find the colour running back on itself as it dries and spoiling the flatness of your wash. If the wash does go blotchy, let it dry completely, then with a clean sponge and water gently sponge it down.

LAYING A FLAT WASH

Mix plenty of colour, more than you think you'll need.

Lay strokes alternately left to right and right to left.

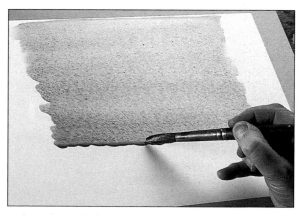

Pick up the pool of colour from the previous brush stroke.

Graduated washes

A graduated (or graded) wash is one that starts with intense saturated colour at the top, then progresses through carefully controlled tonal gradations to a colour so pale that it merges with the colour of the paper at the bottom.

Dampen the paper. Start by mixing plenty of colour, remembering that the paint will dry several shades lighter than it appears when wet. When you are satisfied with the colour, load a brush with full strength paint and lay a stroke of colour across the top of the paper, working quickly. Your board should be tilted so that a stream of wash gathers along the bottom of the band of colour. Next dip the brush into the container of clean water, and without adding more paint to the brush lay another stroke of colour under the first, making sure that you pick up the fluid paint along the base of the previous stroke. Repeat this process until you reach the bottom of the sheet of paper. The wash will gradually get weaker until it merges with the colour of the paper.

Mop up any excess paint which has accumulated at the bottom of the paper, then allow the paint to dry, leaving the board tilted at about a 30 degree angle so that the wet colour does not flow back over the dry colour.

LAYING A GRADUATED WASH

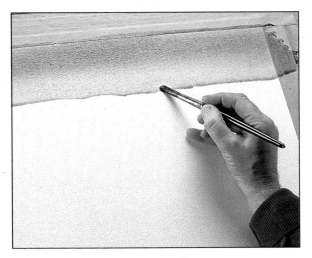

Start at the top with full strength colour.

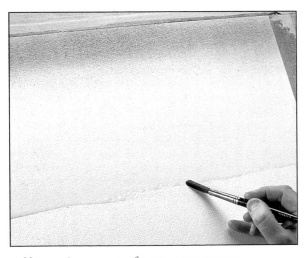

Add increasing amounts of water as you progress.

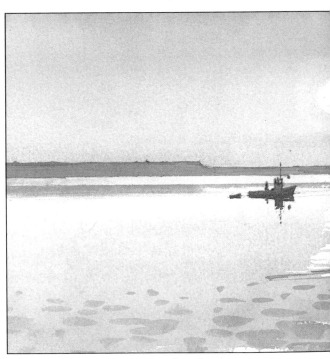

This simple painting relies on graduated and variegated washes. The sky is a graded wash of blue and the strokes of yellow and mauve make a variegated wash at the horizon.

Variegated washes

The term variegated wash usually means two or three colours, rather than tones of a single colour, being merged together. Dampen your paper first using either a sponge or a large brush and clean water, as this will help the colours to merge. Mix your three colours in separate containers. They do not all have to be of the same consistency; you could, for example, make one more intense by using more colour and less water.

Starting at the top of the sheet of paper, paint a strip of your first colour (as if you were laying a flat wash). Quickly, while this is still wet, lay a strip of your second colour, then repeat this with your third. The edges of the colour will spread out and melt into one another. Whatever you think of the initial result, leave the wash well alone until it is completely dry. Additions or corrections can be made then.

Only experience will tell you how much colour you may need and the result will always be rather unpredictable, but practice will help. Changing the tilt of the board can also help you control the merging of the colours. If the board is kept flat, the colours will spread out into each other; as you increase the tilt of the board, the upper layers of wash will run down and melt and merge into the lower ones.

LAYING A VARIEGATED WASH

The first colour merges into the second.

The second colour will then merge into the third.

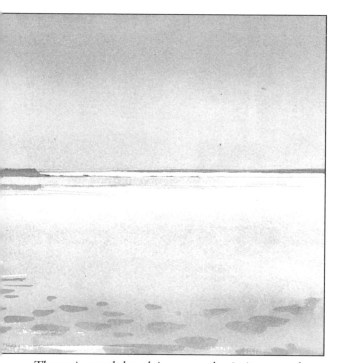

The sea is a graded wash in reverse; that is, it starts at the horizon with a pale wash, and increasing amounts of colour are added as it reaches the bottom.

Wet into wet

'Wet into wet' implies laying wet paint on a wet surface; in this way, the technique is very similar to laying variegated washes in that the second colour you add spreads and merges into the first.

Watercolour relies for its charm upon its transparency and freshness and a lot of this effect can best be achieved by a wet-into-wet technique, particularly in the early stages of painting. While the wash is still wet, areas can be lifted out with blotting paper or a squeezed out sponge or brush, and edges can also be softened. Artists usually work a stiffer, more intense colour into the wet surface of a pale colour. Try to create some of the effects in the exercises on these two pages yourself – they were all achieved by adding wet paint to wet paint. Wet into wet involves a good degree of the unknown, and hence leaves room for the happy accident – perhaps that is the gambling instinct coming out in the artist! Having said that, experimenting with these techniques will give you the familiarity with what watercolour will do to enable you to control the paint. Do not be worried by mistakes but be prepared to learn by them.

Right: A pale flat wash of prussian blue was put over the whole surface, and while this was still wet I dropped a darker blob of the same colour into the centre and allowed it to spread. I then dabbed another blob of darker thicker colour into the middle and before it could be allowed to spread too much, I lifted out some of the colour with a squeezed out brush.

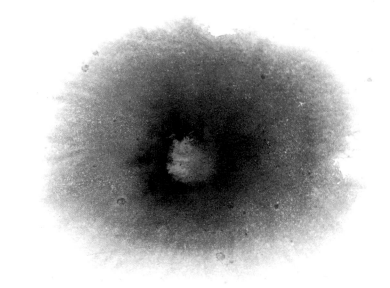

Below right: A pale wash of raw sienna was put over the whole surface, and before it was completely dry random brush strokes of prussian blue were added. Unless the surface is dried off fairly rapidly, the whole will merge together and the effect will be lost. This technique can be useful for cloud effects or foliage.

Far right: A wash of raw sienna was put over the whole surface, and before it was completely dry I applied a squiggle of drier light red very rapidly. This merged in places. This technique is unpredictable but can achieve unexpectedly interesting results.

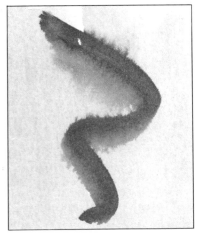

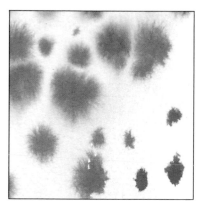

Far left: A wash of cadmium yellow was put over the whole surface, and while this was still wet, I drew a single brush stroke across the middle using a rather thick mixture of indigo. If you don't want the second colour to spread too widely, dry off the paint in front of a fire or radiator, or use a hairdryer, but keep the dryer well away from the paint surface or it will move the colour (see page 36).

Left above: A thin wash of cadmium yellow was put over the whole surface and because the board was kept at an angle, the top started to dry first. I then touched the surface in spots with just the tip of a brush loaded with prussian blue. Where the paper was damper the spots spread wider; the ones near the bottom right hardly spread at all.

Left: This is a graduated wash of raw sienna to which increasing quantities of light red were gradually added. Before this was completely dry, prussian blue was splattered (see page 26) from the bottom upwards. The dots tend to be bigger the nearer they are to the toothbrush, and again the wash is wetter at the lower edge.

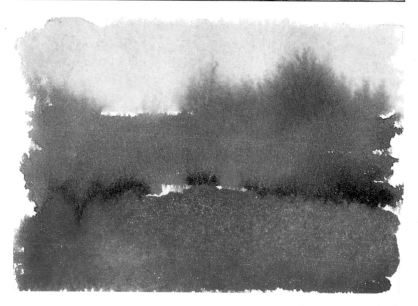

Left: This technique is not easy to control but it is used a lot by artists. A horizontal stripe of cadmium yellow was brushed into the top and while this was still wet a similar stripe of prussian blue laid next to it. The two merged together. The third colour (burnt sienna, with a little light red added) was added while the other two colours were still wet; this then also merged with the prussian blue.

Wet into dry

Working 'wet into dry' – that is, putting wet paint on a layer of paint that has dried, or on dry paper – gives you the greatest control over the application of paint. The paint can be applied direct to the white paper or over another colour. Always be sure that one colour is completely dry before putting on a second. To cover an area, apply the paint in the same way as for a wet surface wash, starting at the top and working down the paper from side to side. Make sure that you have mixed enough colour before you start.

When you work wet into dry, the paint does not run as freely as it does when you work wet into wet because of the resistance of the paper to the paint. This can be useful, however, as it gives the colour a sparkling effect which you don't get when you work wet into wet, because the colours blur. Wet-into-dry techniques should always be used for painting round intricate shapes, and for painting details.

It is sometimes useful to drag the paint across the paper using a fairly dry colour, or to paint with a quick brush stroke which will often produce a broken effect at the end of the stroke. This effect, which is very typical of the medium, is easier to achieve on a Rough or Not paper.

Splatter

Splatter relies on dots of paint of various sizes for its effect. It is fairly random since you have little control over where the spots of colour will go but it is a useful technique to master.

Dip an old toothbrush or hog hair brush into paint until it is well coated but give it a shake to get rid of surplus liquid. Hold it over the surface of your paper and gently draw a craft knife blade towards you through the bristles. This will create a spray of paint, with larger dots of colour the nearer they are to the brush. When this is completely dry, a second colour can be splattered over the first. Masking tape can be combined with the splattering to create shapes and patterns.

SPLATTERING

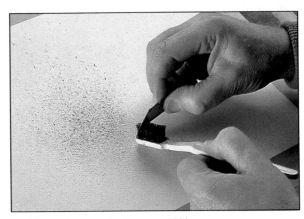

Build up colour gradually to avoid blots.

Stippling

This wet-into-dry technique is useful as it is easily controlled and gives a vigorous effect. Modelling of light and shade can be achieved by varying the size of the dots, how closely they are packed together and, of course, by the use of different coloured dots. It is possible to get brighter secondary colours such as green by mixing blue and yellow spots. In this way the colours mix in the spectator's eye at a certain distance to give a brighter and clearer green than one can get by mixing on the palette. This is the basic theory of the Pointillists.

A brush that has lost its point can sometimes be an ideal tool for this technique. Don't get the brush too overloaded with colour or you will find your dots are in danger of running together. Hold the brush nearly vertical and dab the colour on.

If this technique is executed with very fine dots, the painting can come to look like a photograph and in Victorian times artists used it for this very reason. But the science of colour theory as evolved by the Impressionists and Post-Impressionists has given this technique a modern application. Comparing it with splatter, you have more control both on where it goes and over the size of the dots.

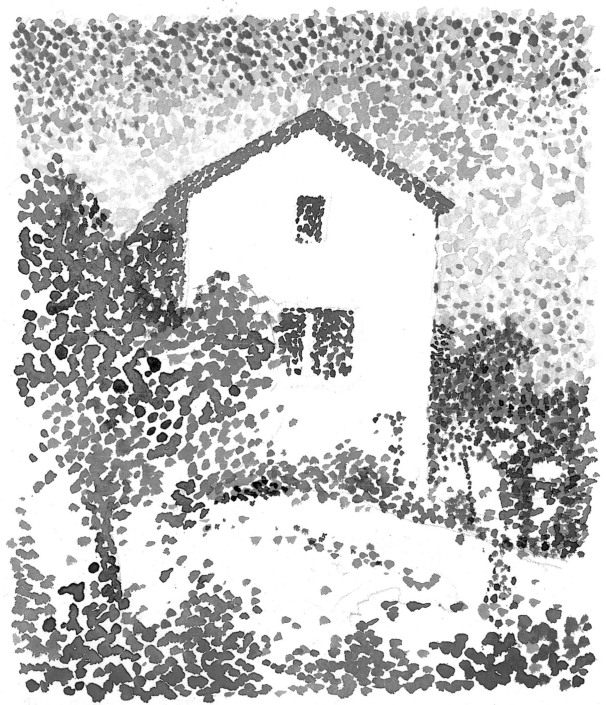

I selected this subject for this exercise because it was simple and lent itself well to stippling. The dots on the near foliage and in the foreground are larger and further apart than those behind the house to create a feeling of distance, and a sense of light and shade. For this painting, I used the point of a number 4 sable-haired brush. Do not overload the brush with colour if you intend to try this technique, as the dots may run together.

Project: Painting a still life

A still life is simply an arrangement of inanimate objects. Usually these objects are brought together by the artist, but a still life could also be a collection of items from the corner of a room or on a shelf, or a completely random group of objects or plants. A still life is a good choice of subject for a beginner, since the objects are easily available and tend to be familiar, and because of this, you know their basic structures. When you are arranging a still life for a painting at this stage, don't make it too complicated or include too many colours. Instead, as I have here, select a few objects that have differing textures and whose tones contrast.

You will need
- ☐ a drawing board with stretched paper
- ☐ two jars of clean water
- ☐ paints
- ☐ brushes
- ☐ a white plate or palette
- ☐ a stick of charcoal
- ☐ a soft pencil and eraser
- ☐ a cotton rag
- ☐ a sponge

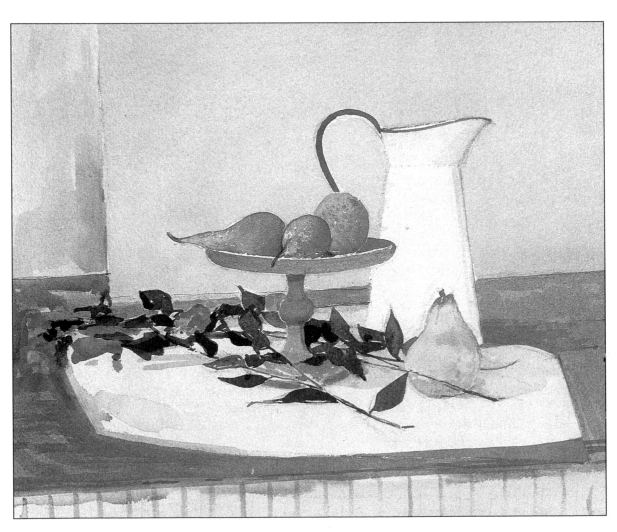

Preliminary sketches

Set out your work space and start with everything clean. You will need a table on which to lay out your materials and work. Prop your board at about a 30 degree angle to the left-hand side of your table (if you are right-handed) – this will leave space on your right for materials. Work in a good light; it is usually better to have the light source slightly from the left (again, if you are right-handed) although this, of course, is dictated to a certain extent by where you arrange your still-life group. You will need to stretch your paper beforehand (see page 12) so that it is dry by the time you want to start work. For this project, I have used a ½ Imperial sheet of Not 90lb (185gsm) watercolour paper. I would recommend at this stage that you have two stretched pieces of paper ready. You'll find you worry much less about making a mistake and therefore paint in a more relaxed way if you have the freedom to discard a sheet if something goes wrong. Arrange your materials on the right of your board so that you can easily reach your paintbox and the water.

Don't try to produce a painting exactly the same as mine, but use this as a guide to method. I chose the objects for my painting partly for their contrasting textures and tones. The smooth, polished enamel jug and plain flat background are played against the texture of the pears and orange and the movement in the leaves. In choosing and arranging your group of objects you may consider some of the following factors, but don't let these suggestions confuse or intimidate you – skill in composition will grow with experience:

1 the size of the objects – try to vary them;
2 the dominant colour – decide whether you want the finished picture to be warm or cool;
3 try to include some straight lines, and some curved or wriggling shapes;
4 try to have one object that attracts the eye first – this can be achieved by colour, size or definition.

Try several arrangements of your objects and perhaps make several small pencil sketches. These

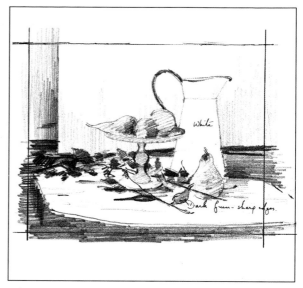

The preliminary sketch to establish composition and tones.

The drawing is sketched in on the stretched paper.

are probably more use if the tones are scribbled in, rather than being in line only. These preliminary sketches are a great help in clarifying the picture in the artist's mind.

Once you have decided on your still-life arrangement, sketch the main lines of your composition on to your sheet of paper with a soft pencil or stick of charcoal.

Softening an edge with a clean moist brush.

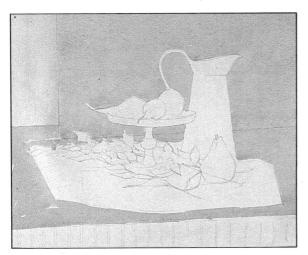

The first two washes on the painting.

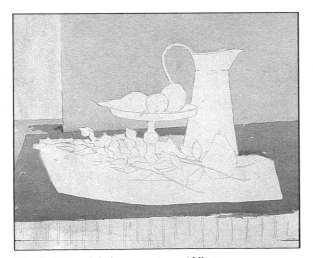

The darker wash helps to create a middle tone.

The initial washes

Once you have established the drawing, you are ready to paint. Initially, I laid a flat wash of raw sienna over the whole surface of the paper, apart from the jug, which will be the lightest area of the finished painting. An initial wash of one colour over a large area of the painting like this unifies it and will hold the later colours together. It also gives an overall warmth to the painting, which, because watercolour is a transparent medium, will come through all the later colours to the finished painting.

While the raw sienna wash was still wet, a thin wash of cadmium yellow was flooded into the upper left of the picture and on to the table top. After allowing this to dry completely, I added the warm pink/brown over the table area and the background; this was made up with a mixture of raw sienna and light red with a very little alizarin crimson added. Again this was put on as a flat wash, starting at the top and working down. Before this was dry, to avoid a hard edge between the colours in this part of the painting, I softened the edge of the upright on the left-hand side with a clean moist brush.

At this stage, there are really only two washes on the paper and, with drying time, it probably took me about 15 minutes.

Adding the darker washes

The previous washes had obscured some of the drawing so I strengthened this slightly, although still keeping the lines light – you don't want the drawing to dominate the finished painting. The single darker wash on the table top was added next. This was made up with burnt sienna and light red, and was deliberately not laid too flatly to give a feeling of surface. In any case, it would be overpainted for greater contrast at a later stage.

It is always useful to establish some of these larger washes in a painting first as they help to create a unity of colour (in this case a warm glow). The smaller details and stronger contrasts will be left until later.

30

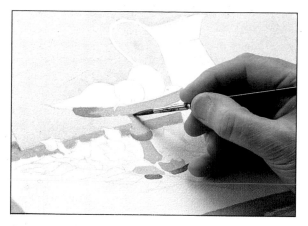

Overpainting the darker portions of the fruit stand.

The cool grey shadow helps to create form and space.

The first details

The stand holding the fruit was painted next. This colour was a wash of neat burnt sienna, which was allowed to dry. However, this left the stand without any sense of light and shade, so to create this impression I overpainted the darker portions with another wash of the same colour. I then started on the pears, initially applying a wash of viridian mixed with cadmium yellow. The quince was also painted with a wash, this time made up of a mixture of cadmium yellow and a little cadmium red. While this was still wet, a little of the green used on the pears was gently blended in. I used a wet-into-wet technique in this area to avoid any harsh contrasts. The softly blurred yellow and green here were intended eventually to contrast with, and complement, both in colour and feeling, the dark, crisply and freshly painted leaves.

At this stage, although I intended the finished painting to be warm, I felt that everything in the picture was getting *too* warm, so I added some cool grey to the upper left-hand side of the picture, deliberately leaving the wash uneven to emphasize the smooth wash of the background. I also used the same colour for the shadow of the quince. The yellow of the foreground was added next – a wash of cadmium yellow.

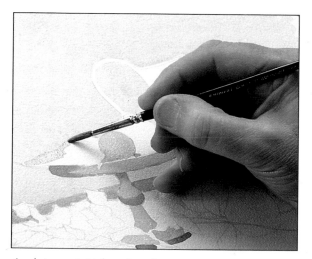

Applying an initial wash to the pears.

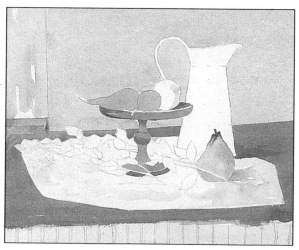

The first details have now been established.

Stippling the pears adds texture.

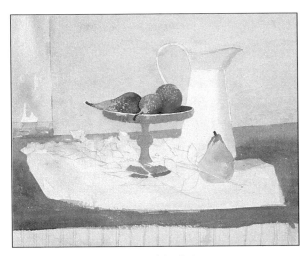

This completes the painting of the fruit.

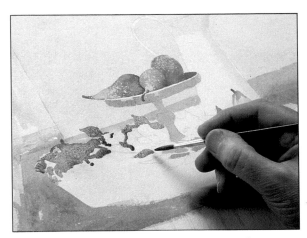

The darker leaves are the last details to be painted.

Adding texture

The painting was beginning to appear but was still flat, and so now was the time to give it dimension by adding the textures. The orange was painted with a wash of cadmium yellow and a little cadmium red, which was allowed to dry. I then added more cadmium red to the colour on my palette and painted on this darker colour, leaving small islands of the paler colour showing through to create the impression of the fruit's texture. The darker colour on the pears – a mixture of viridian and raw sienna – was applied with a stipple technique, leaving some of the lighter colour showing through. At this stage too the shadow on the white jug was painted. This was a wash of indigo with a touch of raw sienna added, and while it was still wet, I softened the edge with a clean moist brush to enhance the shadow effect.

The darker details

The darker details will bring the picture to life, so they need to be painted crisply and freshly. For this reason, I have left them until last. The colour for the leaves was made with prussian blue and burnt sienna, which I painted over all the leaves and stalks. Then, to give variety and depth, I created the darker areas by putting a mixture of indigo and viridian wet into wet. I also used a dilute mixture of this colour to paint loosely over the left-hand side of the picture, since I felt that the grey I had previously painted did not bring that area of the picture alive enough.

The final touches

Finishing details are added to sharpen the image, and bring the whole painting together. The blue of the jug handle was cobalt blue and the richer brown on the table was overpainted to give that area more texture and life. The shadow of the quince was then moved. I did this by dampening it with clean water and sponging it down. Finally, I loosely laid a pale green wash in horizontal stripes to indicate the shadows of the leaves, and to help create the horizontal plane of the table.

Mounting (Matting) your work

When the painting is finished, decide where you want the mount (mat) to cut it. A mount defines the boundaries of your painting (and hides the rather untidy edges). Generally, I would suggest you use a 2-sheet white mounting card next to the watercolour with a 4-sheet off-white mounting card 6mm (¼in.) larger laid over the first one. For a painting of this size, margins of about 75mm (3in.) at the top and sides, and 90mm (3½in.) at the bottom will be about right.

Don't forget the old adage: if at first you don't succeed, try try and try again. Watercolour is not an exact medium – there will always be an element of chance about anything you paint. A painting can be going quite well and then suddenly something goes wrong – a colour runs badly, for example, or goes dirty. You can sometimes resurrect a painting in cases like this, but often I find it's best to start again. (This is why I suggest you should have two sheets of paper ready stretched.) I can assure you that all the practice you do will be worth while. As you become increasingly familiar with the medium you will gain in confidence and find that your work is improving.

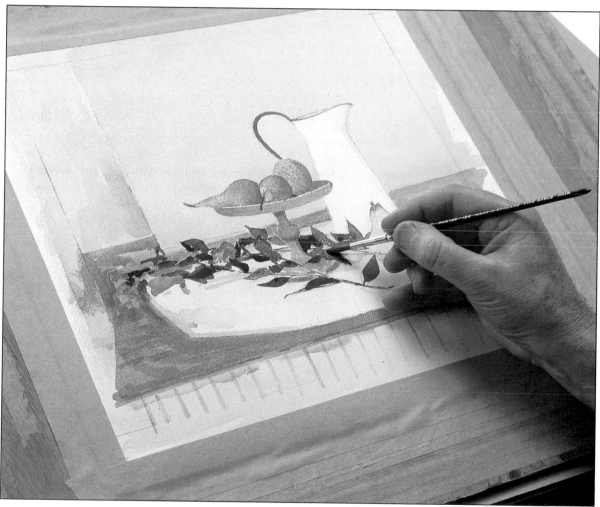

The finishing details, painted crisply and freshly, bring the painting to life.

Further techniques

The kit of the artist is not confined to just paints and brushes, but blotting paper, sponges, hairdryers and many other household objects have their uses. The applications of these are not intended as tricks – they are part of the genuine vocabulary of the watercolour painter, to be used if and when they are considered necessary to strengthen an image. All painters develop their own techniques; the following demonstrations represent only a small selection of those possible.

This does not mean that you should ever try to use all these techniques in a single painting, any more than it would be advisable to use all the colours in your box on one watercolour. Perhaps you would only use one or two of these techniques in any one painting. I have tried not to include a lot of fringe materials and techniques, because they may just confuse. However do experiment, perhaps try drawing with a stick dipped in watercolour, or use washing-up (dishwashing) liquid to obtain a texture or try scratching a wet colour with the back of your brush. There is no need to use good paper, cartridge (drawing) will do, but just try as many effects as you can devise.

Some artists like using an old-fashioned shaving brush for large washes or even an airbrush. Sometimes in the excitement of making a watercolour you are tempted to try some wonderful techniques like one of these. It might come off, or it might completely ruin your work, but that I'm afraid is the nature of the beast we call watercolour! Do remember, too, that all these techniques are only of use if they help you to express your idea in a stronger way: they are of little or no use as an end in themselves.

You will need
☐ a drawing board with stretched paper
☐ two jars of clean water
☐ paints
☐ brushes
☐ a white plate or palette
☐ blotting paper
☐ natural sponges
☐ masking fluid
☐ razor or craft knife blades
☐ a hairdryer
☐ white candle wax
☐ tissue paper

This sketch (right) is made up of only flat washes and sponged texture. For the three larger trees, I laid a flat wash which I allowed to dry. I then painted some of this same colour on to a natural sponge and gently dabbed the area of the trees – this gives two tones. The darker shadows on these large trees were created by dabbing some of the colour I had mixed for the small tree into the still wet texture. I then just touched some red into this still wet paint to add highlights. The different texture on the small tree was created in exactly the same way but using a finer sponge.

Left: Alternative patterns can be created using string (far left) and lace, pressed into paint and on to paper.

Sponging

Sponging is usually used to add texture to a painting and is a particularly useful technique for adding foliage to trees and bushes, and for creating the impression of greenery (see also pages 44-5). Sponge gives a random, exciting effect, which is not easily produced with a brush. It is a good idea to build up a collection of sponges of different sizes and different degrees of coarseness – also, I find natural sponge far better to use than synthetic. The area to be textured dictates the size and coarseness of the sponge to use.

For a small area, you can apply the paint to the sponge with a brush, but for larger areas prepare the wash in a saucer or deep palette and dip the sponge in lightly. If you get the sponge too wet, the texture will be almost non-existent. If the sponging is applied to a damp area of paper, it will tend to spread and you will get a softer effect; if the surface is dry, it will give a crisp and much more pronounced texture. A tone or colour can also be darkened by successive dabbing with the colour on the sponge and you can, of course, apply two colours, but again if you want the end result to be a crisp texture, allow the first to dry before applying the second.

Sometimes a wash which is too flat and uninteresting can be brought to life by sponging a light texture on to it. A touch of a dark colour dabbed with a sponge into still wet paint adds a random lively feel to an area of a painting. I achieved the highlights in the picture below by dabbing touches of red into the still wet sponging.

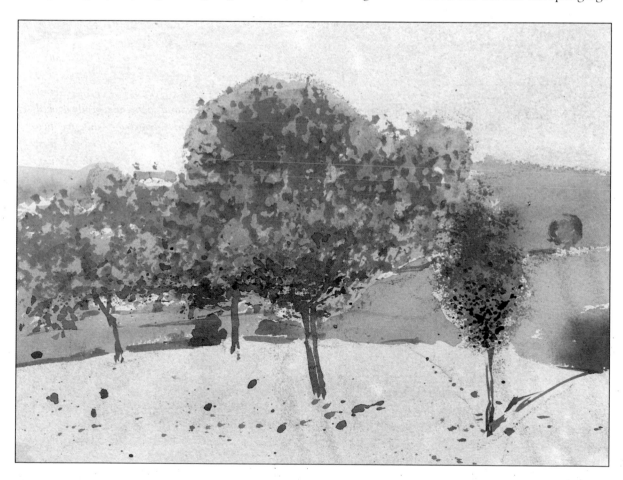

Drying and blowing

Blowing the paint surface while it is still wet spreads the colour, but is very difficult to control, and so is not used very often. Sometimes, you can achieve a happy accident, but I rarely use this method myself.

Lay a flat wash over the whole area, and while it is still wet use a hairdryer close to the surface to blow the paint where you want it to go. As it dries, it tends to granulate the colour, which can be very attractive. You can also blow wet paint through a drinking straw, although this again is a rather random technique.

Controlled drying, on the other hand, can be very useful. If you dry off an area rapidly, the colour doesn't have time to spread or run back on itself. You can use a hairdryer for this too, but don't put it too near the paper surface or you risk moving the paint. I use an electric fire (space-heater) with a guard. It seems to suit my technique better – it also helps me to keep warm in my garden studio! Obviously, you should only use a safe fire that is easy to handle, and be confident that you know what you are doing.

Scratching

If a wash, or succession of washes, has gone dull, or their transparency has been lost, you can bring some life back to the surface by scratching the paint off the pinnacles of the paper's surface texture using a single-sided razor blade or a sharp craft knife blade. If the edge is used, either will give an all-over textured effect; if only the point is applied, it will give a more linear quality. However, it is difficult to put a wash over an area you have scratched as the surface of the paper has been destroyed. Also, this technique is only suitable on a heavyweight paper.

It is also possible to take an area of wash back to the white paper with sandpaper. Use a fine-grained sandpaper and rub in a gentle circular motion at the area of paint you wish to remove. Don't be impatient – take the paint off gradually. Depending on the quality of the paper you use and the area of colour you have removed, the destroyed surface will take a wash, although not very well. Small areas of white, however, can be flicked out with a blade or painted on with chinese white watercolour.

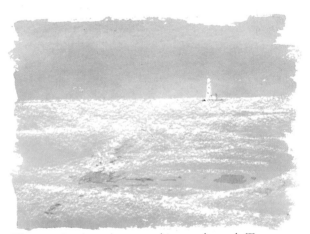

The granular effect here was achieved by blowing a wash of viridian with a hairdryer. When this was dry, I applied the dark green blobs, and then blew the wet paint through a straw. Some control over the general direction in which the paint goes is possible but this is a rather random technique.

This exercise shows how scratching can be used. Two simple flat washes were applied to the paper, and left to dry. A craft knife blade was scratched flatly over the water area to create the broken effect. The point of the blade was used to give the sharper white lines and the lighthouse.

Wax resist

When you draw with candle wax it doesn't completely cover the surface of the paper, particularly on a Rough or textured paper. Use a piece of ordinary white candle and rub it on to the parts you want to keep white. A subsequent wash cannot penetrate the wax but will lie in the crevices between, thereby giving a mottled broken effect. It is therefore unlike masking fluid, which will give you a clean, hard line (see pages 40–1). As the wax will stay on the paper you cannot change your mind and try to put a wash where the wax remains.

This technique is more suitable for larger, broader watercolours, because, although it can be controlled, it is only done so with difficulty. It is more usually used in a random or haphazard way; it does, however, produce interesting results on occasions.

Similar results can also be achieved with white wax crayons.

Above: Using wax as a resist repels a subsequent wash.

These poppies demonstrate how wax resist can be used. After sketching the design in pencil, I roughly drew in vertical lines using a piece of white candle. This acted as a wax resist and granulated the green wash which I laid over it. I then laid a light flat wash of raw sienna and cadmium red for the poppies. When this was completely dry, I again drew in a rather random way with my piece of candle to suggest the growth of the petals. This wax resist was overlaid with a wash of cadmium red mixed with a little cadmium yellow. Finally, the leaves were laid as a flat wash and parts of the flowers accentuated with darker streaks of red and purple.

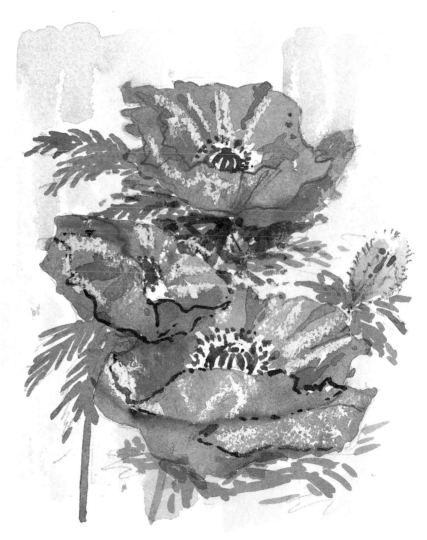

Dabbing off and blotting

Apart from its use in removing colour, blotting paper is a real necessity for the watercolour artist. If you keep moistening an area of paint with water and blotting off you can almost eliminate a colour. Also, it is very useful to have a sheet of blotting paper on your work surface so that if you overcharge your brush you can lose some of the surplus by touching the blotting paper with your brush. In an emergency, such as a colour running or a drip of paint, blotting paper is indispensable.

Although you can use very absorbent tissue paper in the same way as blotting paper, it is more often used for creating texture. It gives a random effect, particularly useful in creating foliage. It is possible to use any absorbent material in this way – muslin, rags, string, or natural objects such as leaves. All of these can be either pressed into paint, placed on to the paper and rubbed on the back to create a texture, rather like using a stencil. Alternatively, place the dry material over wet paint on the paper to lift off areas of paint, thus creating a texture.

Scumbling

Although more widely used in oil painting, scumbling can also be useful to the watercolourist. Scumbling is really a dry-brush technique, used mainly for breaking one colour over another without obliterating the first. Many artists, including Eric Ravillious and Edward Bawden, have used it very successfully.

Load a brush with paint, keeping it fairly dry, and apply the pigment with a circular movement. It often helps if you pinch out the brush to splay

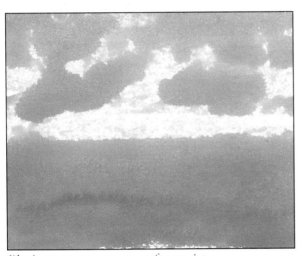

Blotting paper removes areas of wet paint.

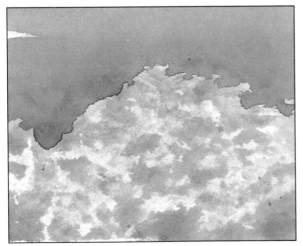

Blotting with crumpled tissue creates a texture.

HOW TO SCUMBLE

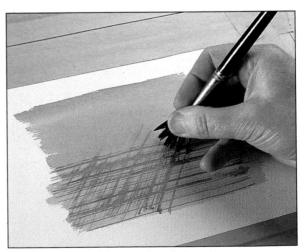

Splay out the brush hairs and comb the colour on.

the hairs and virtually comb the colour on. Areas of white paper or a previous colour will show through. This effect does not work so well on a smooth-surfaced paper.

Similar effects can also be achieved by dragging the brush over the surface of the paper. For this the colour needs to be fairly dry. You can also achieve this dry-brush look by lifting the brush from the paper rapidly at the end of a stroke – the paint will leave a wispy dry-brush trail.

Lifting colour

Variations of this technique are used considerably by artists. Basically, when you have laid a wash of colour and while the paint is still wet, lift out the required area by wetting a large brush, squeezing it dry and mopping out the colour. The following are some common adaptations of this idea:

1 The edges of a wash can be softened by using a brush or sponge moistened in clean water and squeezed out to enable it to mop up surplus wet paint. This is illustrated on page 30.

2 If a wash has dried with a hard edge and it needs to be softened, wet inside the edge for about 6–12mm (¼–½in.), then, with a brush, work the paint in a circular motion until you can see the edge disappear. Blot off the water either with a squeezed-out brush or blotting paper.

3 If a colour has dried too dark and needs to be lightened, sponge over the whole surface with clean water and mop up with a squeezed-out sponge or brush. The harder you sponge, the more colour you will remove. This technique can be used over fairly large areas to lighten the colour a little overall. You will not, however, be able to get back to pure white paper because the watercolour will have left some stain.

4 Small areas and lines of paint can be lifted off with cottonwool buds (cotton swabs).

5 When the paint surface is completely dry you can lighten part or the whole of an area by using a soft eraser. However, if you rub too hard you will render the surface unusable for a further wash.

LIFTING TECHNIQUES

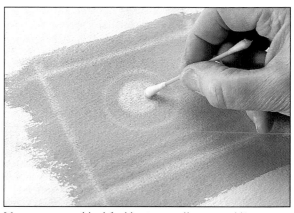

Use a cottonwool bud for blotting small areas and lines.

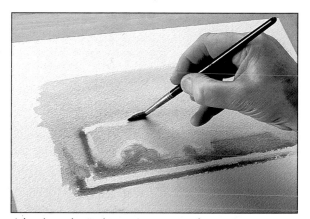

A brush can be used to mop out areas of wet paint.

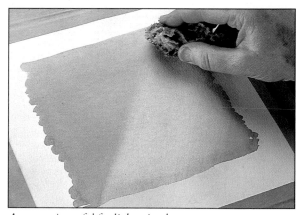

A sponge is useful for lightening larger areas.

Masking fluid

Masking fluid is a liquid rubber solution which can be applied to areas of your painting where you don't want a wash to go. Its main value is that it will enable you to achieve clean crisp edges and, after it has been rubbed off, the surface can be painted over or left white. In this it differs from wax resist (see page 37). Masking fluid can be applied with an old watercolour brush, an oil hog-hair brush, a stippling brush, the edge of a piece of cardboard, a dip pen for lines and dots, or a ruling pen for long straight lines. Shake the bottle well. A word of warning: always clean your brush or pen in clean water immediately after use to remove the fluid completely.

The masking fluid can be applied to the white surface of the paper, or it can be used over an existing wash to preserve parts of that when you intend to paint another wash over the top. In both cases, the surface of the paper must be completely dry when you apply the fluid.

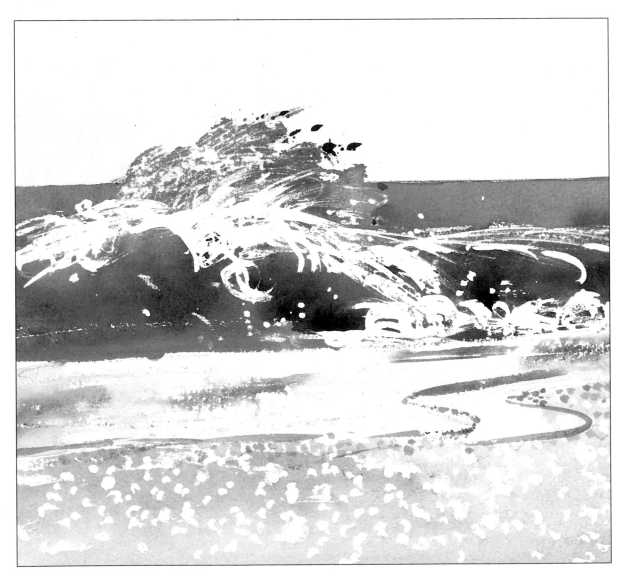

Right: In this instance, masking fluid was used to create a texture of tiny flowers in the foreground, and also on the frames of the greenhouse. After the masking fluid had been rubbed off, leaving white paper, watercolour was applied over some of these areas.

The impact of the breaking wave in this illustration is created with masking fluid. I used masking fluid and a brush to draw in what would be the white of the breaking wave and dabbed on the white spots of the foreground. I then painted in the sky area and the water, creating the darker shadow under the wave, added wet into wet, and the foreground. When all the washes were dry, I rubbed off the masking fluid. At that stage I felt that there should be more white in the breaking wave, so I scratched a little of the colour away from the top of the wave.

USING MASKING FLUID

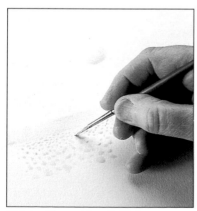

Paint with masking fluid those areas you wish to remain white.

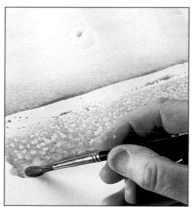

When the fluid is dry, apply washes to the paper in the normal way – the unpainted surface will be protected.

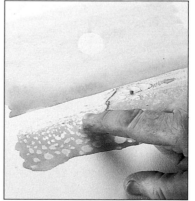

When the washes are completely dry, rub off the mask. Make sure your finger is clean!

Project: Painting a landscape

For this project, I decided to use an existing drawing that was made 'on the spot' as a basis from which to paint. The original was drawn in charcoal and pencil without any colour. This was backed up at the time with a sketch and colour notes. This

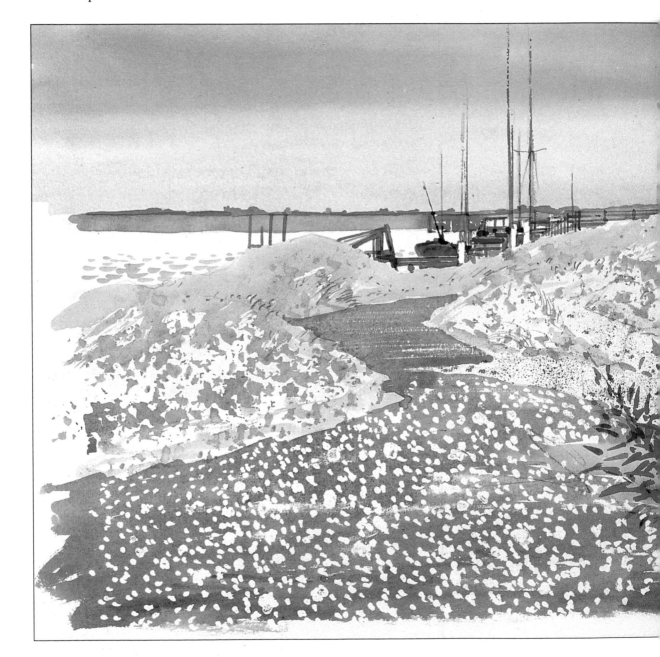

demonstration offers the chance of using many of the techniques outlined so far. Don't try to copy it exactly – it is important to select a subject that interests you and one that you feel confident enough to tackle – but try to pick a subject that will give you the opportunity to try out as many techniques as possible. Finally, don't worry if this doesn't turn out to be a masterpiece. As an artist, these are early days for you: the

You will need
- [] a drawing board with stretched paper
- [] two jars of clean water
- [] paints
- [] brushes
- [] a white plate or palette
- [] a stick of charcoal
- [] a soft pencil and eraser
- [] natural sponges
- [] masking fluid
- [] razor or craft knife blades
- [] a toothbrush
- [] a ruler
- [] drinking straws
- [] a piece of cardboard

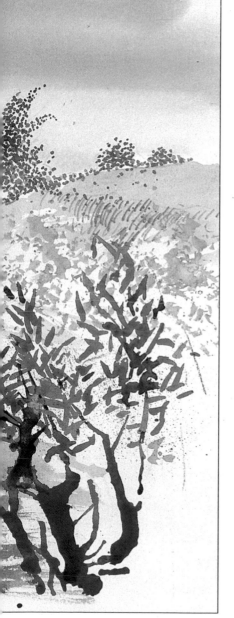

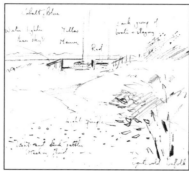

The notes on colour (above) and original 'on the spot' drawing.

important thing at this stage is that you enjoy your painting. The paper selected for this project was Arches 140lb (295gsm) and I stretched two ½ Imperial sheets as described on page 12. It is always worth having a spare sheet of paper ready stretched when you start on a project. If you do find that you want to start again, it is very annoying to have to wait several hours for a newly stretched sheet to dry naturally. The size of the painting here is 330 × 430 mm (13 × 17in.) so there will be a margin inside the gumstrip.

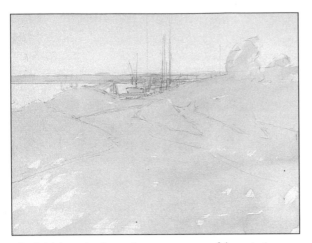

An initial wash of raw sienna over most of the painting.

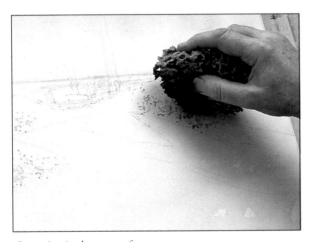

Sponging in the areas of grass.

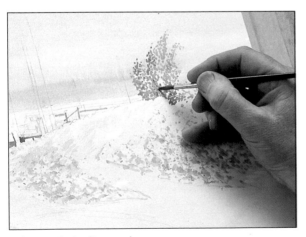

The initial stippling on the trees.

Preliminary sketches

To start with, I lightly sketched the main lines of the composition on the stretched paper in charcoal; this enabled me to correct the drawing or composition easily with an eraser. After I was satisfied, I dusted off the charcoal with a rag, then established the drawing more carefully in pencil. Treat the paper with care – don't draw too heavily or rub out too vigorously and use a fairly soft pencil, such as a 2B.

The first washes

I then laid a flat wash of raw sienna over the whole composition, except for the sky and the water. This was done to help unify the subsequent colours and to give an overall warm glow to the painting. If there are a few islands of white left, however, it will give more variety to the colours you use in overpainting.

Don't be fussy about the painting's edges; run the colour beyond the limit of your composition – the mount (mat) will cover this anyway.

The sky area was put in next. I first sponged over it with clean water, then prepared the three washes on separate palettes. I started at the top with a wash of cobalt blue. This was allowed to run down for about half the sky area, then, while this was still wet, one horizontal brush stroke of cadmium yellow was flooded into it and allowed to run down. While this was still wet the mauve colour was put in with two horizontal strokes. This produces the variegated wet-into-wet wash. I mopped up the excess wash that had accumulated at the bottom with a squeezed-out brush, then allowed this to dry.

The broad details

The grass was a mixture of viridian and cadmium yellow, applied with a large size sponge. Painting leaves or grass in detail is tedious. An open-textured sponge creates a texture which parallels that of grass and leaves more easily. I gave some areas a second dab of colour after the first was dry for added depth. When all this was dry, I put a few

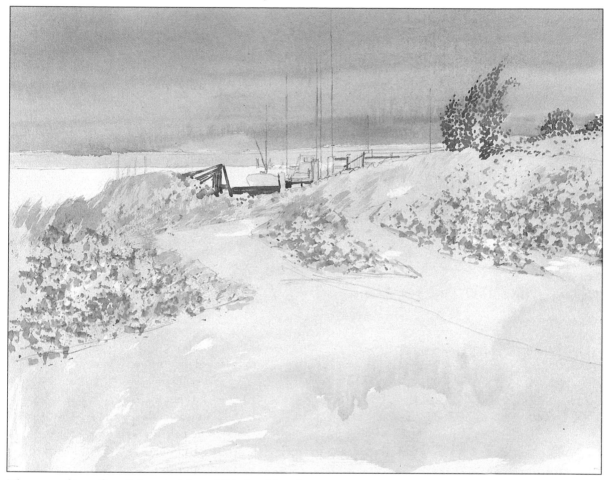

The range of tones from light to dark is established at this early stage.

strokes of paint on to the staging. I then started to stipple in the trees with a mixture of prussian blue and raw sienna. This helped me to establish the range of tones, from light to dark, at a fairly early stage of the painting.

Adding texture

I used masking fluid on the path, and applied it with a brush in blobs. After allowing it to dry, I put a wash of indigo and alizarin crimson over the path area with some raw sienna run into the foreground. When all this was dry, the masking fluid was rubbed off. The texture resembling stones was created by putting a few darker blobs of colour over the top of this whole area.

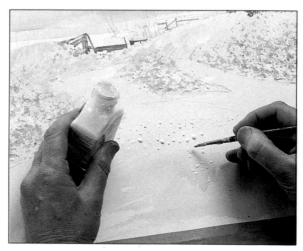

I used masking fluid on the path.

Maintaining unity

Normally in a painting it helps to keep the unity if you work over the whole surface and don't finish off one part at a time. For this reason, I added more interest to the foreground by applying some splatter and scratching areas away. I then intensified the stippling on the trees to make it darker, and added more colour and texture to the grass. I also did some more work on the staging, including painting an area of cadmium red on one of the boats. This ensured that the staging area did not fall behind the rest of the painting. The distance was added in grey and some brush strokes of pale cobalt blue in the water.

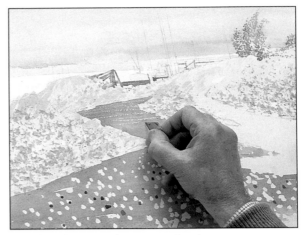

Scratching here is used to create a flat plane.

The darker details

At this stage, I did some preliminary work on the masts. I painted the edge of a piece of cardboard and used this as a template for them.

Although my original 'on-the-spot' drawing did not have the bush in the foreground I decided to add it to the painting. I find it often helps to have something fairly large and dark in the foreground to make the distance lie back. The bush was made by mixing a dark wash of burnt umber, putting a few wet blobs at the bottom edge, then blowing it with a drinking straw; the leaves are the natural shape of brush strokes applied very freshly and allowed to dry.

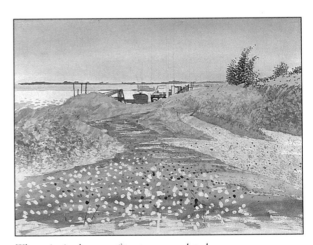

The principal areas of texture completed.

Unifying the composition

Towards the completion of a painting, it is helpful to stand back and assess what needs to be done additionally to unify the composition. At this stage, I was able to see what the final effect of the painting was going to be, and decide how I should finish it.

I decided that the focal point of the staging and the boats still needed quite a lot of attention. The focal point of a painting is often finished to a higher degree than the rest of the composition but it is difficult to ascertain exactly what needs to be done until the rest of the painting is finished. The staging needed to be painted crisply since to a

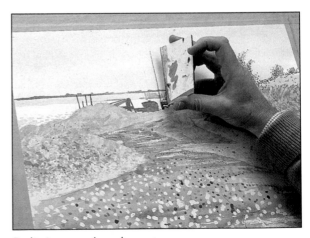

Preliminary work on the masts.

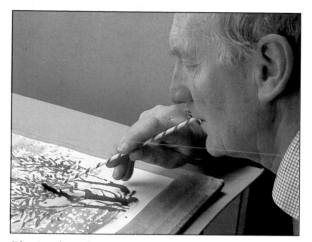

Blowing through a straw to indicate branches.

certain extent the success or failure of the finished watercolour depended on it.

The contrast of the dark staging and the feeling of light, particularly on the water, is one of the major factors in the success of the painting and one of my main reasons for selecting this subject. I enhanced the feeling of light by increasing the contrast between the banks and the water, and between the water and the masts and rigging of the boats. I painted these details with a fine brush to ensure that they had the crispness and freshness that I wanted to achieve. To finish off, I added a few darker touches here and there to give sparkle.

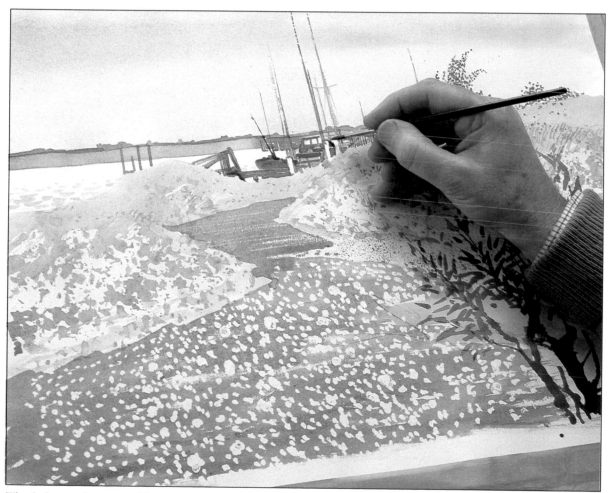

The darker touches, painted last, add contrast and sparkle to the painting.

Subjects for the watercolourist

Almost any subject is suitable for making a watercolour – the success of a painting depends on your vision as an artist and your ability to express your feelings. It is through these feelings, expressed in a visual form, that you can help others to see and appreciate the world about them in a new way.

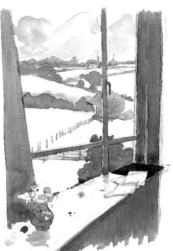

Painting familiar things like your garden or the view from your window, even your pet (top), has many advantages.

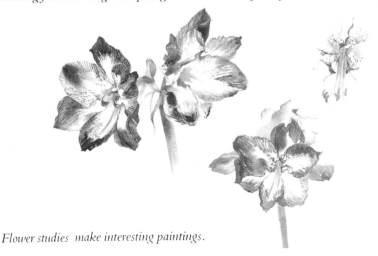

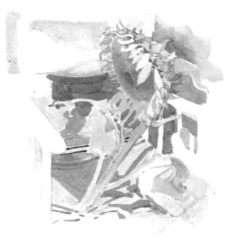

Flower studies make interesting paintings.

Choosing your subject

It is important in selecting your subject to see things freshly and in terms of painting – that is, in terms of tones, colours, textures and lines, rather than objectively or figuratively.

There is no need to go miles from home in order to find a subject to paint; in fact, you will probably produce a more successful painting if the subject is something you know intimately, in your own home or garden, or an area of the countryside you know well and love. Until you have had more experience, it is not advisable to try to paint the figure, particularly nude, in watercolour. Flesh tones are more difficult to achieve in watercolour than, say, in oils. There is the added problem of trying to paint a subject that moves about, and you will have enough problems without worrying about a model who will not stay still. This also applies if you'd like to paint your pets – choose a time when they are asleep!

It is not always possible to sit down with your watercolour kit and paint just when you feel like it, but if you carry a sketchbook around with you you can always make a note of something that interests you. This is also a good way of improving your drawing. Buy a sketchbook that will fit into your pocket or bag and whenever you have a spare moment draw whatever you can see – a pair of shoes, a line of washing, the kitchen sink, the breakfast table, an apple, and so on. Drawing is fundamental to art and it needs to be practised constantly. It does need discipline, however, to enable you to develop the necessary hand-eye co-ordination.

While you are still familiarizing yourself with the medium, don't always work on the same size paper – if you are close to what you intend to paint, try working on a larger scale. Whatever your subject and size of painting, you will need something in the composition that you can use to measure scale; in a still life it could be a particular pot, it may be a tree in a landscape, or just the length of a particular line. This then becomes your module and everything is related to it in scale.

When you are selecting objects to paint, don't worry too much about arranging them: a good painting can be made from a completely haphazard group of items or indeed from something in itself quite insignificant.

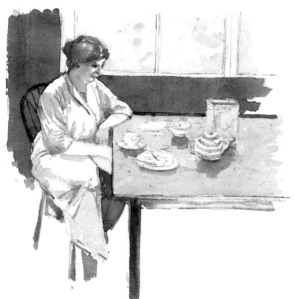

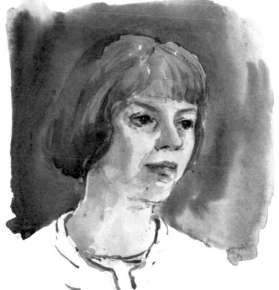

Portraits, full or head and shoulders, though difficult, are worth trying.

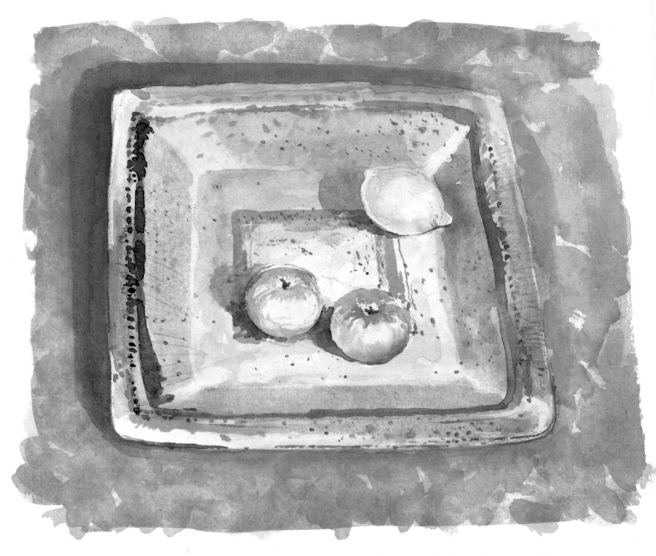

The choice of subject for still lifes is endless – items in themselves insignificant can make interesting compositions.

Finally, although being an artist is fascinating, fulfilling and rewarding, remember that you will always be learning. The more you know, the less you seem to know. But, like anything worth while, you must work at it to reap the rewards. You cannot, therefore, learn to paint simply by reading about it. You must produce lots of paintings to become familiar with what you can (and can't) do. If you develop a love of the medium, and a desire to paint, all the effort and possible disappointments will seem unimportant.

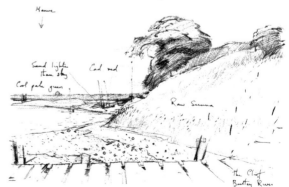

Always carry a sketchbook for quick drawings.

Approaches to watercolour

The paintings on these pages are a selection of historical and contemporary works by artists in watercolour. They show different treatments and different subjects and emphasize that there is no one way to approach a subject – there are as many ways as there are artists. Similarly, there is no one way to use watercolour paint. Andrew Wyeth, Hans Schwarz, Olwen Jones and I use watercolour transparently (this is known as the 'English' method), but Samuel Palmer and Christa Gaa in their works have used gouache (or body colour) – which is not transparent – mixed with the transparent watercolour.

I hope that these examples will demonstrate that watercolour is by no means a precious isolated medium, it is another way of expressing yourself. Most artists are not solely watercolourists or oil painters or draughtsmen they use whichever medium they feel best expresses their ideas at any particular time.

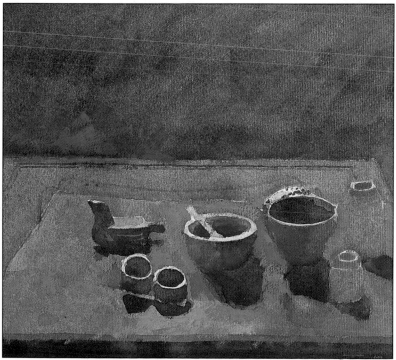

Samuel Palmer 'In a Shoreham Garden' 275 × 218mm (11 × 8¼in.). This example shows how the combination of transparent watercolour with gouache and pen lends itself to a decorative and textural approach. The gouache is used most thickly in the lighter areas.

Christa Gaa 'Still Life with Nepalese Bird' 192 × 216mm (8 × 9in.). This watercolour looks deceptively simple, but the quality of light, composition and colour are carefully considered. The combination of watercolour and gouache expresses the feeling of intense overhead light and atmosphere. The losing and finding of the tones and edge qualities also contribute to making this a very lovely painting.

Andrew Wyeth 'Southern Comfort'
563 × 750mm (21¾ × 30in.).
This watercolour was painted in
1987 and is typical of the work of
Andrew Wyeth. Obviously, the
painting has a strong illustrational
content yet it is so much more. The
very strong composition and limited
use of colour, and the artist's
understanding and care over edge
qualities, give this painting a great
sense of poetry. The texture of the
paint surface, the transparent use of
watercolour and the use of dry
brushwork typify his work.

Hans Schwarz 'Kitchen Jars and
Bottles on a White Table' 500 ×
675mm (20 × 27in.). 'I have only
a white piece of paper and a few
tubes of watercolour to represent this
complex arrangement of jars and
bottles. Faithful representation is
less important to me than a rich
colour pattern and a lively flow of
paint. Green becomes the
predominant colour. From the left
background it threads its way to the
jars on the right. Red, blue, orange,
violet and yellow interrupt the
green, bringing forward and
defining the objects in space.
Juxtaposed complementary colours
– red and green, violet and yellow,
give recession and sparkle.'

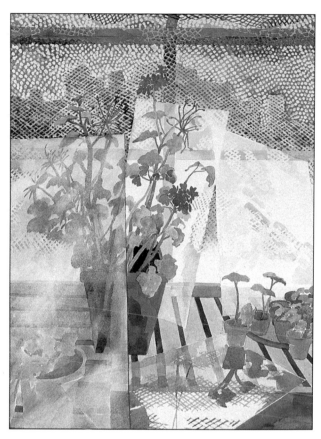

Olwen Jones 'Winter Geraniums' 600 × 475mm (24 × 19in.). 'This watercolour was painted with an afternoon light in my greenhouse. It depicts geranium cuttings overwintering, looking rather sad among the netting used for diffusing light and several odd panes of glass. The light and reflections from the panes were what first attracted me to the subject. The whole composition had a transparent quality with plenty of texture, which I always use a lot in my paintings. I also liked the contrast between the soft shapes of the geraniums and foliage, and the sharp hard edges of the glass. Reflections, whether in glass or a mirror, give an added dimension to a composition; you are never quite sure whether an image is real or reflected. In this painting I used only transparent watercolour and some masking fluid.'

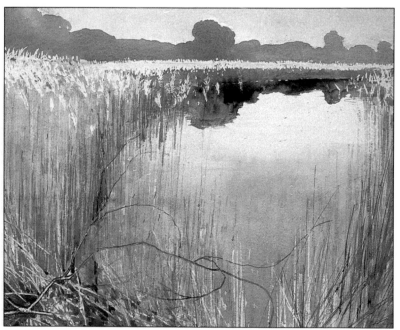

Charles Bartlett 'Lakeside' 437 × 575mm (17½ × 23in.). 'This watercolour was painted in the studio from drawings and notes made on the spot. By working in this way I am able to consider and organize my composition. The feeling I got for the subject was the poetry of place, of tranquillity and stillness and a soft feeling of light on the reeds and in the water. It is not essential in watercolour to use a broken "washy" technique always. The dark silhouette of the distant trees accentuated the light shining on the feathery heads of the reeds. I used masking fluid fairly extensively on the reeds.'

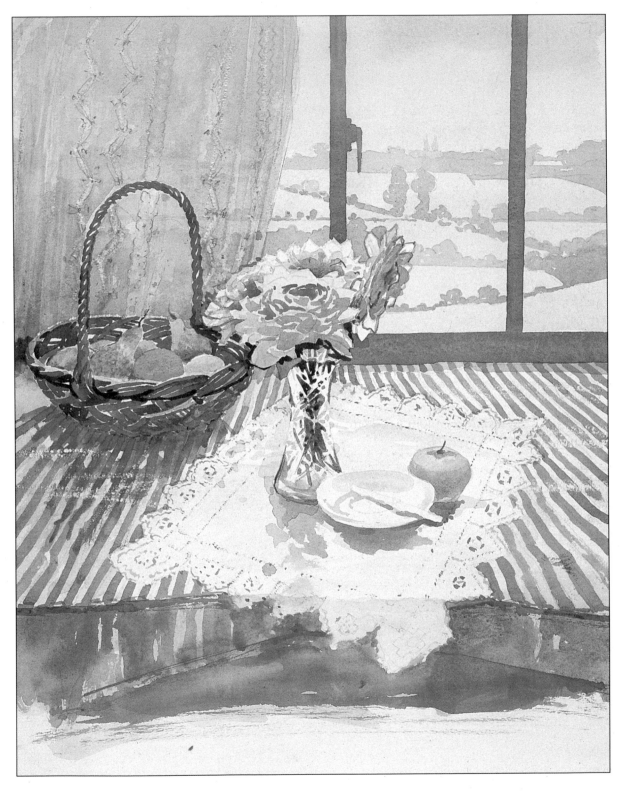

Project: Still life

Art is about expressing oneself and not just copying what happens to be in front of you; it is about ideas and feelings. Above all, it is to be enjoyed. Once you have mastered the basic techniques of watercolour painting, expressing emotion through creating a feeling of light, freshness, sparkle and texture, for example, becomes more important than an accurate representation of what you see in front of you. This is what I try to achieve in my painting. This project interested me for a number of reasons. Probably the most important is the quality of light – I painted against the light on a windowsill in my studio – but I was also attracted by the colour and variety of textures, the light showing through the lace curtains and the stripes on the cloth, which also introduce perspective (the vanishing point is the centre of vision). The purple stripes are a complementary colour to the green of the landscape and apples. This subject also demonstrates the importance of choosing an appropriate eye-level. I selected a high eye-level so that I would be looking down on the striped cloth and into the basket, and also enough of the landscape over the windowsill to give a different dimension to the picture. This watercolour is painted on T.H. Saunders 140lb (295gsm) paper which I had stretched, and the image size is 380 × 310mm (16 × 13in.).



You will need
- ☐ a drawing board with stretched paper
- ☐ two jars of clean water
- ☐ paints
- ☐ brushes
- ☐ a white plate or palette
- ☐ a sponge
- ☐ a toothbrush
- ☐ a knife
- ☐ masking tape



Initial stages

The composition of this watercolour was decided after I had made several preliminary sketches. The drawing was first laid in with charcoal which was then dusted down, and the image was drawn in in pencil. Although the drawing is fairly accurate, I didn't want to labour it as I intended to keep the watercolour free. If you are over-careful with the drawing there is a tendency to fill in the shapes with paint in local areas, and this can produce a very stilted picture.

The sky was painted wet into wet, starting with cobalt blue, grading to pale raw sienna and then purple. The green (a mix of cadmium yellow and cobalt blue) was laid in as a flat wash. Raw sienna was loosely painted on parts of the basket and the foreground, and while this was still wet burnt sienna was flooded into the foreground.

The palest washes were put in first.

The trees were added over the flat wash of the landscape, then a paler wash of thin light prussian blue and a little burnt sienna was carried over the lace curtains and blotted off with blotting paper. The frames of the windows were added after the landscape was dry. I used burnt sienna, indigo and crimson lake for this wash. The apple and the shadow from the vase and plate were also indicated at this stage.

First details

I decided to finish the flowers and vase completely at this stage. Normally I like to keep the whole painting going but flowers move and die, so although the drawing of the flowers was fairly detailed, I painted them broadly to try to keep the feeling of light. The colours I used on the flowers were cadmium yellow, burnt sienna and purple (mixed from prussian blue and alizarin crimson). The cut glass vase was painted using cadmium yellow and cobalt blue, keeping the edges and contrasts sharp. I then lightly indicated the plate and knife.

Creating the flat planes

At this stage, I was anxious to establish the flat plane of the table and create a feeling of space. I felt that the stripes on the tablecloth would achieve this so I decided to tackle them next. Once they were done, I could see that they had achieved the perspective and plane of the table top.

The painting was now beginning to take shape and it was easier to appreciate what was needed next. I decided I could not delay work on the curtain and basket as these would establish if the painting was going to be successful or not.

The background completed.

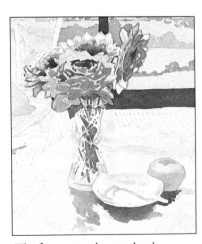

The flowers nearly completed.

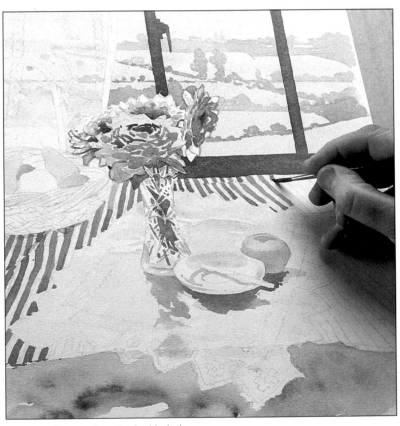

Painting the purple striped tablecloth.

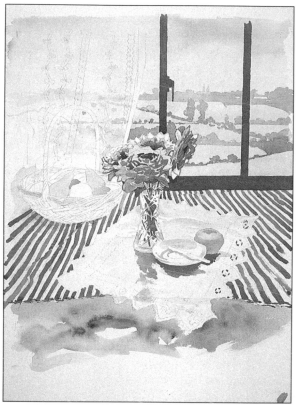

The tablecloth establishes the plane of the table top.

Adding warmth

The pattern on the lace curtain was painted using masking fluid. I tried to consider the counter-change brought about by the holes in the lace being seen against the sky and landscape. I put a warm pale wash over the curtain (once the masking fluid was dry), and when the wash was dry, rubbed off the mask. I now felt that the purple stripes made the table top too cold so I added some broken raw sienna to the lace mat.

Creating light

To help establish the overall feeling of light in the painting the dark note of the basket was added next; this was important as it balanced the composition. I painted it in warm dark tones (burnt umber and burnt sienna) to help bring it forward from the landscape and background.

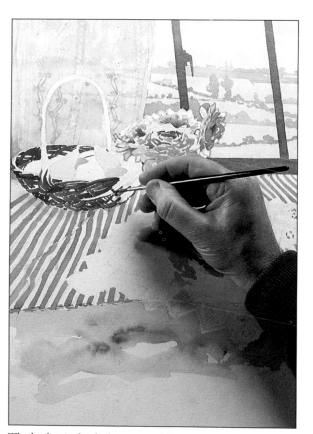

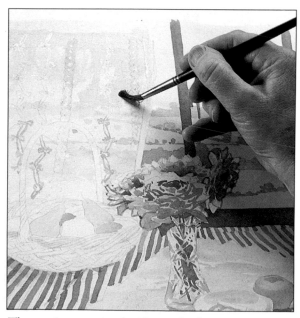

The curtain was painted with a wash of raw sienna.

The basket is the darkest note of the painting.

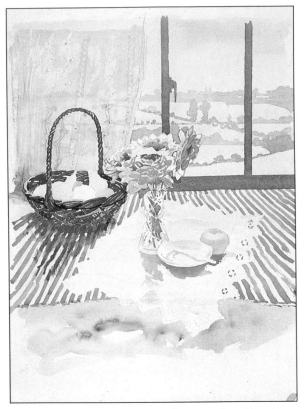

The basket's shadow makes it 'sit down' on the table.

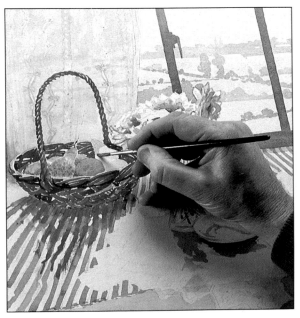

Covering the final areas of white paper.

As I was painting against the light, the basket cast a deep shadow and I put this in next as it helped to make the basket 'sit down' on the plane of the table.

Covering the paper surface

In any painting before you can really begin to see the final result it is necessary to get all the white paper covered. The fruit in the basket was the last unpainted area and so I tackled this next. I was careful to retain a light top edge to the basket since it would help to convey a feeling of light. The shadow from the window frame falling on the cloth was put in with a simple wash of cobalt blue – blue is a colour that will lie back in a painting.

The finishing touches

At this stage, the painting was nearly finished; the surface was all covered and I felt the unity of the composition was coming together. I could now see what was needed to finish the painting – the curtain was not dark enough, the flowers and vase needed some strengthening, the foreground wasn't dark enough, and the lace table mat required work. These final touches are vital in any composition, they often bring the painting to life. At this stage, you may want to link the dark areas together, or to emphasize a particular movement.

The lace on the table mat was suggested rather delicately so as not to lose the overall feeling of whiteness and so I used a very fine brush. The outline shape was created by the dark stripes of the cloth; I felt it would be more satisfactory painted in this way as in this kind of painting outlining the shapes themselves may flatten the composition. Also I did not want to lose the feeling of light and the delicacy of the painting – where the far edge of the plate melts into the lace mat, for example.

The darker details

It now seemed to me that the landscape and background were too light for the weight of colour in the foreground. I decided to darken the curtain and also fill in the light hole behind the

basket. Having done that, I felt that the flowers didn't seem to take their correct place in space because they were so pale, and so I darkened under their front edges. This pulled them forward, and linked the dark of the basket to the dark horizontal frame of the window. I did some scratching on the curtain and on the tablecloth to give small flecks of white which you often get when you are looking into strong light. This also helped the basket's shadow 'lie down'. Finally, I painted the foreground vigorously in a dark warm colour to pull the table edge forward.

When you finish a painting and stand back to look at it, you will probably always feel that some parts are more successful than others. Do try to restrain yourself from starting to niggle at these areas – this is the easiest way to destroy the feeling of freshness and light you have achieved.

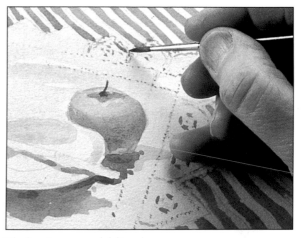

The lace is suggested delicately.

The flowers needed darkening at this stage.

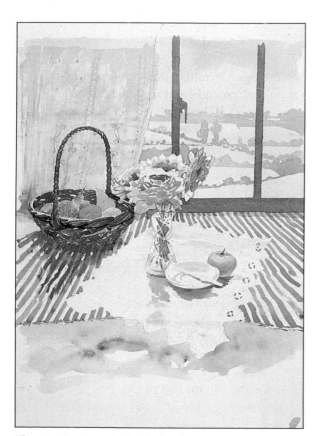

The painting is nearly finished at this stage.

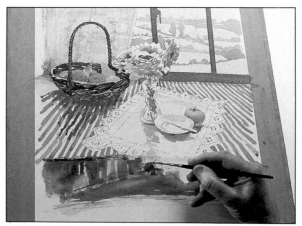

The warm foreground pulls the table edge forward.

Index

Acknowledgements

Swallow Publishing wish to thank the following people and organizations for their help in preparing *Starting in Watercolour*. We apologize to anybody we may have omitted to mention.

Unless indicated otherwise, all artwork is by the author.

Christa Gaa, p 51 (foot); Olwen Jones, pp 41, 53 (top); The Provost and Fellows of Eton College, Windsor, p 7 (top); Hans Schwarz, p 52 (foot);

Reproduced by kind permission of the Trustees of the Victoria and Albert Museum, London p 51 (top); © Andrew Wyeth, Wyeth Collection, p52 (top).

Thanks to Richmond College of Adult Education for testing the projects in this title.

The materials and equipment illustrated on pages 10-18 were kindly loaned by CJ Graphic Supplies, 35-39 Old Street, London EC1 and 2-3 Great Pulteney Street, London W1; Daler-Rowney, 12 Percy Street, London W1.